For Wylodean
with love,
Willa Ghant 92

LIFE CAST

(noun)

An object created
by taking a direct
impression of a
living subject.

WILLA SHALIT

LIFE CAST

BEHIND THE MASK

BEYOND WORDS PUBLISHING, INC.

Published in conjunction with the Touch Foundation

BEYOND WORDS PUBLISHING, INC.
13950 NW Pumpkin Ridge Road
Hillsboro, Oregon 97123
503-647-5109

Printed in the United States of America
This book is printed on recycled paper.

In memory of Nancy Shalit,

who taught me to see behind the mask.

SPECIAL THANKS TO:
Gilbert Paper Company, Patron
Guide Dog Foundation for the Blind, Inc.
Johnson & Johnson Orthopaedics, Inc.
Teledyne-Getz

DESIGN: Principia Graphica
TYPOGRAPHY: Textures™, Blue Sky Research
PAPER: ESSE® by Gilbert
PRINTING: Lithographix, Inc.
BINDING: Roswell Bookbinding

THE EARTHSONG COLLECTION: Books that plant
trees, save eagles, and celebrate life on Earth

Light on the Land
Moloka'i: An Island in Time
Quiet Pride
The American Eagle
Wisdomkeepers
Within a Rainbowed Sea

**OTHER PHOTOGRAPHY BOOKS FROM
BEYOND WORDS:**

Cattle Kings of Texas
Pacific Light
Outward Bound

Library of Congress Cataloging-in-Publication Data

Shalit, Willa, 1955–
 Life cast : behind the mask / Willa Shalit.
 p. cm.
 ISBN 0-941831-80-9 : $29.95
 1. Shalit, Willa, 1955– . 2. Celebrities—Portraits.
 3. Plaster casts. I. Title.
 NB237.S47A2 1992 92-14236
 730'.92–dc20 CIP

Life casting without proper instruction can be
dangerous and could result in personal injury.
Do not attempt to make a life cast without proper
instruction. This book is not intended to provide
instructions for life casting. It is offered for
informational purposes only and is not intended
as instructional. Readers of this book should not
attempt to make a life cast based on any information
provided in this text. The author and publisher are in
no way liable for any use or misuse of the material.

CONTENTS

REFLECTIONS

In these times, when people feel so far away from each other, Willa's life casts create communication through touch and spirit. The castings are gifts of love—these people have given their essence into the casts, and then the casts are offered to the hands that reach out to see them. • It's been a joyous experience for me to feel the faces cast by Willa, to see the faces of my family. I'm happy to be involved in this touching work and to be a part of bringing Willa's work to the world. STEVLAND MORRIS • AKA STEVIE WONDER • MAY 1992

• • •

I was surprised to see what I really look like in three dimensions. I think I look serene, somewhat serious, but also mischievous underneath—ready to burst through with a laugh at any moment. • There are so many dimensions to our personalities that are revealed in our faces. I think it's wonderful to give people an opportunity to know another person by touch, that wonderful sensation usually forbidden to us. Touching is the way we all discover the world as children. AMY TAN • JANUARY 1992

H E L E N

It is not for me to say whether we see best with the hand or eye. I only know that the world I see with my fingers is alive, ruddy, and satisfying. Touch brings the blind many sweet certainties which our more fortunate fellows miss, because their sense of touch is uncultivated. When they look at things, they put their hands in their pockets. No doubt this is one reason why their knowledge is so often vague, inaccurate, and useless.... There is nothing, however, misty or uncertain about what we can touch. Through the sense of touch I know the faces of friends, the illimitable variety of straight and curved lines, the exuberance of the soil, the delicate shapes of flowers, the noble forms of trees, and the range of mighty winds.

K E L L E R

LIFE CASTING

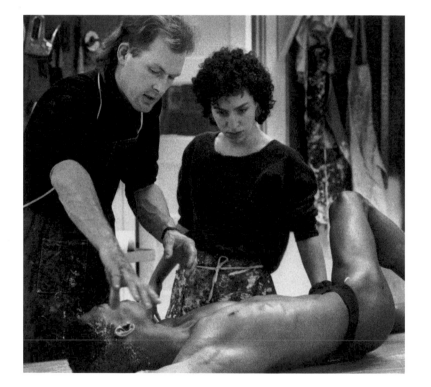

A PERSONAL JOURNEY

The blue-haired ladies aren't sure about the nude bodies. I have come to Cincinnati for the opening of our "Please Touch!" exhibition at the Contemporary Arts Center. The show features seventy of our pieces of life-cast sculpture: impressions made directly from life of a great assortment of humans, ranging from the face of the Dalai Lama of Tibet to the giant arm of basketball player "Dr. J." I walk a group of museum volunteers through the exhibit, explaining the work to them and offering to answer any questions they might have. The city is still reeling from the controversy over photographer Robert Mapplethorpe's exhibition. The flap has drawn the national spotlight to Cincinnati's Contemporary Arts Center. It has won the battle and succeeded in keeping the exhibit up, but in the process it has lost most of its corporate sponsorship. I hear whispers of concern. Is it appropriate in the current climate to display resin casts of nude dancers' bodies for schoolchildren to touch?
• These particular life casts have special significance for me, as they are the first project my partner Dean Ericson and I co-created. I had been making life casts of faces for years

when I met Dean, a sculptor, in New York. Dean and I discovered that we shared an overwhelming impulse to celebrate and document humanity by exploring the human form: Dean creates sculpture, and I cast from life. As Dean visited my studio, offering me technical suggestions, he became excited about the unique possibilities life casting offers. We found that our strengths were complementary and realized that together we could create works of art that neither of us could produce alone. Dean's technical expertise allowed us to attempt more ambitious life casts, and we decided to spend a full year working together perfecting the art of casting bodies in motion. • Life casting is essentially a collaborative art form. When I cast prima ballerina Natalia Makarova's leg *en pointe* in 1983, I began to see the potential of uniting my technique with a dancer's art. In December 1987, Dean and I approached the Alvin Ailey American Dance Theater about casting members of the company, feeling that the Ailey dancers' tremendous ability to express themselves through their bodies was a perfect vehicle for body casting. We spent time watching our subjects move. As the dancers stretched and posed their nude bodies for us in the privacy of our studio, we were inspired by their magnificence and capacity for expression. On a practical level, we were faced with obstacles in casting body parts. There were technical problems in dealing with body hair and muscle fatigue, as well as, naturally, a certain amount of awkwardness in the beginning about touching and being touched. But because of our mutual commitment to such a groundbreaking project, we worked through this and, I believe, were able to capture the essence of these gifted performers, concentrating and even magnifying their raw

vitality. • When the Ailey castings, titled "Reaching," were first shown at the Fort Lauderdale Museum of Art, we heard that middle school children were being detoured around the installation during their tour of the museum. John De Andrea's life-cast sculpture *The Sphynx*, a nude female, real in every detail, *was* on the tour. Was it because a silk rope around the sculpture protected her, and the audience, from the danger of touch? • At the Scottsdale Center for the Arts a blind thirteen-year-old had informed me that she thought the life-cast bodies were sinful. The concerned director of the Fort Wayne Museum of Art in Indiana even sent her curator of education to our studio at the College of Santa Fe to inspect the pieces before allowing the "Reaching" exhibit to proceed. The exhibition was a tremendous success. • I try to calm the volunteers' fears about the Cincinnati exhibition. I suggest that they let kids explore the sculptures in any way they wish, and I reiterate that art doesn't have to be a staid, boring experience. Now, in Cincinnati, the question has come up

again. I feel sad that the human body has become taboo. I show them respectable casts of American presidents and renowned actors. They all like Clint Eastwood. This is a raw casting, created with a gelatin called alginate, that results in a highly detailed surface. The mask is a pure facial landscape showing the actor's face with eyes closed and no hair. This meditative portrait deals only in essentials: no flashing eyes and smile, no coiffed hair, and no clothing. What is left is an image of Clint Eastwood distilled into something essential and enduring. The image is definitely accurate—the mold fit!—but to many people it seems unfamiliar. Here is a face with real substance, one that sits there, like a Buddha, inviting study and reflection, revealing essential underlying truths. • Life casting slices through time. The absence of contemporary trappings elevates the life cast to a timeless and universal entity. Future generations will be able to see that we were people very much like themselves and that the past is really not so distant. • A tiny, energetic, silver-haired woman asks, "How did you get started in this?" This inevitable question is difficult to answer. My favorite image of myself as a child is contained in a plaster handprint that I made in kindergarten, painted sky blue, and signed "Willa." The little hand was perfect and it was mine; there was no other in the world like it. At the time, I looked at photos of myself critically: that kinky hair! that olive skin! The handprint was simpler, more essential; it seemed to contain more of me. Best of all, I could touch it. I could put my hand inside the handprint and see how

perfectly it fit. As time went on and I grew older, the handprint provided tangible evidence that I was leaving childhood behind. • I made my first life cast when I was twenty. The face belonged to my youngest brother, Andrew, who was twelve at the time. My mother had been in and out of psychiatric hospitals from the time I was eleven, and so, by default, the mothering of my five siblings had fallen to me. As a result, Andrew has always seemed part son, part brother to me. Making this mask was a way of playing with Andrew—I was in the habit of entertaining him—and a way of experimenting with a willing subject. • To make the mask, I placed straws in Andrew's nostrils so that he could breathe, slathered petroleum jelly on his face, mixed plaster and water and smoothed it over his features, and then waited. An hour later, I held something very precious in my hands: the still-boy face of my brother, every shape and pore of the form dear to me. I felt deep satisfaction at having created this solid, tactile image, which, in spite of its crudeness, held the essence of Andrew. • But why did I feel the urge to continue improving my life-casting technique and to keep making these casts in hundreds and thousands over the years? This is the part that remains a mystery to me. All I can say is that life casting has me hooked. It seems to be some kind of gateway, opening the way to a truer reality for me. As a little girl, I knew that when I went to sleep my homemade dolls came alive and danced around the room. Part of me still really believes that artists, as in the myth of the Greek sculptor Pygmalion, can bring their creations to life. Life casting also helps me penetrate the surface of a person and find their essence. My adored mother's illness had taught me not to judge a person by his or her behavior, even though it might be bizarre or incomprehensible. I have always tried to see behind the mask, and life casting is my way of doing this. • Over the years, I have worked toward this goal by experimenting with materials and developing techniques that help me animate my work. So many life masks end up having the appearance of death masks. One way I have avoided this is by finding ways to make life casts quickly so that the experience is brief and pleasant. When my subjects are relaxed, they do not recoil from my hands, and their vitality shows clearly in the mold. • I am careful to use nontoxic materials, as it would be counterproductive to use materials that might harm the very person whose spirit I wish to illuminate. Neither am I interested, as some might think, in taking a piece of a person's soul away. In fact, the opposite is true. I hope that by revealing my subject's true self through a life cast I give something that will enlarge his or her spirit in a profound and lasting way. Life casting allows me to feel compassion for my fellow human beings, to feel close, to make contact,

to not feel separate. I know that this is what I am supposed to be doing with my life. • The volunteers and I pause in front of the life cast of Brooke Shields. This was a gift she gave to her mother for Christmas. Brooke saw it as a picture of her inner self, without makeup and hairstyle. She wanted to give her self to her mother. When Brooke saw her face she told me that she was so happy to see herself calm and centered on the inside. "That's what lasts," she said. "It does look different," one docent comments. "She almost looks like a man!" says another. I agree with that. I think Brooke's androgyny is a great part of her beauty. This is a different kind of portrait, I remind them. It is a "spirit" portrait, revealing the essence, not the façade. It shows us what lies behind the mask. • Someone informs us that television crews have arrived to film Dean and me making a life cast of Larry Donald, the amateur super heavyweight United States boxing champion—and a local hero. The "Please Touch!" exhibition will open tonight, and we're casting Larry for the benefit of the press and the exhibition. We make our way downstairs to the atrium adjoining the Contemporary Arts Center, where a curious crowd has collected to watch the casting. • I hold Larry Donald's face in my hands. The six-foot-four, 225-pound boxer is gentle and soft-spoken. I have been told that he considers himself an artist, that he paints and draws. While Dean sets up the materials and the camera crews get their

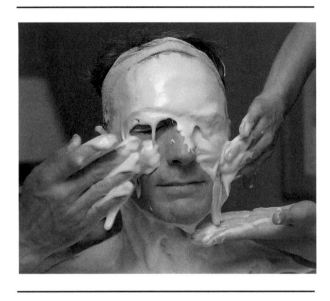

equipment ready, I focus on Larry, trying to make the crowd disappear from our interaction. I ask him about his art. "Yes," he says, "and I write poetry, too." I am reminded of my experience with another poet/fighter: Muhammad Ali. I was surprised to find that he was a warm and kind person whose strength lay in his brilliant wit and great athleticism, not in meanness. Ali's fist is hanging in the gallery upstairs at the Contemporary Arts Center. It's a hugely popular piece. Visitors exclaim, "Look! My fist is as big as Muhammad Ali's," expecting him to be a giant. Actually, his hugeness is in his spirit, not his physical size. • Larry has a fight tonight, so he will not be able to come to the opening. He sits quietly as Dean and I smooth alginate gel on his face, down his neck, and over his broad, smooth shoulders. We are creating a portrait through touch. Unlike a photo, painting, or sculpture, there is no space between Larry and this impression. I feel the smoothness of his skin and the life surging through his body, and I know that these three minutes are *it*—the connection that we make at this moment in time will transform white powder and water into a living image. • I whisper into Larry's ear, telling him to focus, to concentrate. Smoothing my hands over his body, I feel his life. The intimate experience of touching Larry's face allows me a unique and penetrating understanding of him. As I stand several inches away, gazing at the form of his face, feeling the contours of eyebrow ridge, cheeks, chin, the

muscles of his neck, his sloping shoulders, in just a few minutes I am able to obtain impressions of his personality and spirit that transcend whatever preconceptions I may have had when I walked in. Larry is focused inward, and I see and feel his inner face. I sense a kind young man, someone who is earnest and committed, hardworking and strong. I see the archetypal form of the boxer. • The crowd is watching, intensely interested in this weird mummification performance. Minutes pass. I remind Larry to breathe, telling him that it will be just a few more minutes. I can feel him calmly giving himself to the process. The time is up. We remove the mold to the cheers of the crowd. As Dean tends to the mask, I gently wipe Larry's brow to clean it of any vestiges of plaster. • When I show Larry his face, he smiles broadly. He feels honored to have been immortalized in this way. I feel honored to have been allowed to get this close. Larry's manager ushers him off to training. "God bless you," Larry says before he walks away. • Two hours later we return to the Contemporary Arts Center for the opening of the exhibition. I take a deep breath, grip Dean's hand, smile, and enter the crowd. Hundreds of well-dressed Cincinnatians mill around, beaming at one another, exclaiming over a life-cast face, tentatively touching a nose or cheek. A group gathers around the casting of the Dalai Lama of Tibet. It is the first time that this piece has been shown. A man in a suit asks me, "Did you really touch his face?" "Yes," I say, "I did." "Why

are his eyes closed?" I explain that my subjects always have their eyes closed when I cast them. In fact, I have heard of only one case of open-eye casting: Michael Jackson had his eyes as well as his face cast for the *Thriller* video. His eyeballs were anesthetized and scleral lenses inserted for the process. That's too extreme for me. And how relaxed would people be if I were doing all that to them? It's not exactly the way to get a pure inner portrait. Sometimes Dean sculpts the eyes of a life cast open — and he is a magician at it — but we chose not to do this with the Dalai Lama. We wanted to keep it pure. His Holiness was meditating during the casting, and the closed eyes show his inner focus. • A petite, dark-haired woman in a strapless dress rushes toward me and introduces herself as Diane Dunkelman, chief fundraiser for the center. Diane's hair is pulled severely off her face, emphasizing her features. I like that. She asks if she can commission me to cast her face while I am in town. I accept with pleasure. It'll be fun to explore the form of her chiseled features. I think back to when I wanted to erase my own Jewish face, when as a child, I wanted to look like the pictures of the pretty blonde ladies in magazines. I decided that I would change my name to "Karen," straighten my kinky brown hair and dye it blonde — and of course my nose had to go. When I was thirteen, I told my parents that my Jewish nose, which was referred to as "roman" or "classical" by diplomatic elders, got in the way of my vision. I couldn't

see around it, so it would have to be reduced! I actually convinced myself that this was true; by walking around cross-eyed, I could see its bony bridge. Some faces seemed to open doors to happiness, fame, and riches, while some seemed to court rejection and anonymity. I wanted a good face. Now, looking at Diane, I remember that through this work I've learned, over and over again, that I really don't prefer the button-nosed beauties. I like to see sculptural and spiritual strength, full form and extreme angles. • There is a gentle tap on my shoulder, and I turn and look straight at a remarkable face: kind, blue eyes looking out from a thousand creases that crisscross a smiling visage. It is Pat Harmon, an old friend of my father, Gene Shalit. Pat was the sports editor at the *Champaign News Gazette* while my father was a student covering sports for the newspaper at the University of Illinois. Pat befriended him and made him feel he knew what he was doing— heady stuff for a kid of about nineteen years of age. In 1951 Pat was named sports editor of the *Cincinnati Post*, a position he held for thirty-four years; he is now the curator at the College Football Hall of Fame. I have been expecting Pat—though who could expect such a magnificent face! I know that he is a special person to my father. Only a handful of men hold this place in my father's heart, and I had been looking forward to meeting this man who thinks of my dad as "young Gene," not as a celebrity. • When I was fifteen, my father was catapulted to fame by being on television. Although he tried to shield us from the spotlight, to most of the world I became, first and foremost, Gene Shalit's daughter. This identification seemed to be more important than anything else about me. It was clear that people were interested in him because of his fame, and interested in me because I was close to that. Anything else I said, did, or was, paled in comparison. In some ways I enjoyed the second-hand attention and the association with someone I loved and admired, but I felt invisible and resented that. Looking around a room full of life casts of celebrity faces, I realize that, in the beginning, my work offered me a way to come to terms with this challenging issue. • The next day, in the dining room of the Clovernook Center for the Blind, Dean and I demonstrate a basic face-casting technique to a group of blind adults. They are gathered closely around us so that they can "see" what we are doing by touching at every stage. The wooden floor of the worn, scrubbed Victorian mansion has been covered with a drop cloth to protect it from the plaster drippings. Founded in 1903 by two sisters, Florence and Georgia Trader, Clovernook is no longer a home for "putting away" the blind. Nowadays it serves

as an education center, training its visually impaired clients so that they can enter mainstream America. I am told that the name was changed from Clovernook Home and School for the Blind to Clovernook Center for the Blind because the previous appellation seemed too reminiscent of the days of Helen Keller. • I reflect on this. I was six when I learned about Helen Keller. Fascinated, I walked around with my eyes shut, wishing for a Teacher to appear. I loved dancing with my eyes closed, because when I did, the world seemed clearer to me. I was brought down to earth with a rude shock just a month later, though, when I was expelled from junior ballet class for refusing to open my eyes during pirouettes. Later, as a teenager, I walked down dark paths in the woods with no problems. I innately understood how it was possible to see without eyes. Through my work, I honor Helen Keller who in her world of darkness and silence touched the faces

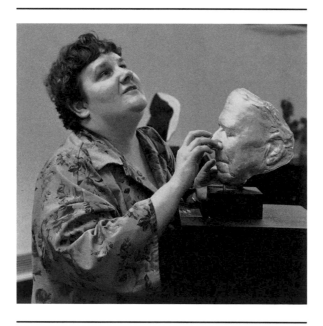

of those around her, felt the vibration of their step, and smelled their aroma, free of the myriad visual impressions that dominate the perceptions of the rest of us. • Imagine a world without faces. In sharing the life-casting technique with the blind and visually impaired, I offer them not only the chance for creative expression but also the opportunity to see their own faces and the faces around them. • Helen Levine is president of Clovernook. Pat Harmon had mentioned that Helen's son has "something to do with music," and

I learn that he is in fact James Levine, conductor of the Metropolitan Opera. Helen and I exchange pleasantries about her son and my father. She offers to be our model as we demonstrate mask-making. • A woman named Jeannie Walsh is sitting in the circle. Jeannie has come all the way from Los Angeles to "see" the exhibit and to participate in the workshop. A gentle, elegant woman in her mid-thirties, with soft brown hair cut to her shoulders, Jeannie has had three years of blindness, brought on quickly by a degenerative disease, and is valiantly adjusting, living life with courage and passion. Jeannie touches the wet plaster gauze as I hold it out to show the group. It is passed around the circle. Some of the students seem dull and uninterested. Is this just more occupational therapy, like making potholders and planters? • I have finished applying the gauze to Helen's face and invite the students to file past and touch the plaster. The mood lightens. Everyone is engrossed in feeling the hardened plaster against the face below, able now to understand the concept of direct impression. • Once removed, the cast gets passed from one hand to the next. Fingers gently probe the surface, feeling the form and texture. Sure enough, every line and wrinkle of Helen is in there. Later, Helen writes: "I was delighted to meet both of you, even though I shudder at the lines and wrinkles when I hold my mask up to the sun. I guess a good dose of reality is good for all of us!" • Working in teams,

members of the group settle in and begin to create their own masks, to get their own dose of reality. One by one, eyes and noses disappear as faces are covered with plaster. Even the most aloof student is now totally absorbed in the process. • During the lunch break, Diane Dunkelman arrives for her face-casting, bearing delicious New York–style deli food. Her hair is wrapped in a handkerchief and her face is bare. "I *never* appear in public without makeup on!" she admits, laughing. • I sense in Diane the nervousness that most people feel before they have their mask made. Even after years of mask-making, it still amazes me that so many people are afraid of seeing their own face. It is as if the face were hidden, which of course it isn't. • Once Diane is calm and seated comfortably, we proceed to make her mask. Our subject sits centered and still. Minutes later, when we remove the mask and show

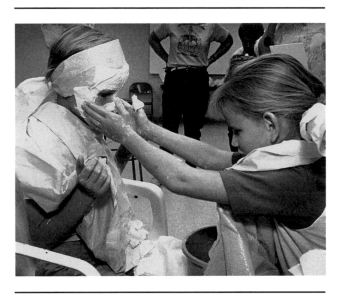

her her face, she gasps: "All I could hear was your soothing voice. I couldn't see, of course, but it felt like I was looking inward at my face, then looking through my face into my soul. This mask is not the illusion I work on creating through makeup. It is really me." • Diane tells us that she would like her face cast in bronze for her art collection. She has decided that she likes the face behind the makeup. She has decided that she is *art*. • As I am washing the plaster off my hands, the woman who is my whole reason for being in Cincinnati arrives. Moe, otherwise known as Morleen Getz Rouse, took

charge of planning the exhibition a year ago and has energetically orchestrated all the elements of the exhibition and my visit, down to the last detail. It has been great working with Moe, and the experience has created a friendship, not just an exhibit. • Later, we are on our way to the home of Deborah Kendrick, who will interview me for her column in the *Cincinnati Enquirer*. Deborah is blind, so she has a particular interest in my work. We sit on her comfortable couch and chat. Deborah asks me how I came up with the idea for a touchable exhibit of faces. I recall reading that Helen Keller was once asked what she would do if she were granted three days of vision. She replied that she would gather all her friends in one room and "look long into their faces. I should let my eye rest, too, on the face of a baby so that I could catch a vision of the eager innocent beauty which precedes the individual's consciousness of the conflicts which life develops… and I should like to look into the loyal trusting eyes of my dogs…." It struck me that this brilliant woman, who experienced an immensely rich and varied world of sights unseen, wanted to see faces, not a sunset or the view from a mountaintop. Helen Keller did touch faces, apparently able to perceive great nuance of character in those she touched, much as sighted people do when they look at faces. • As a result of my fascination with faces and my realization about how important they are in my world, I wondered if visually impaired people

would enjoy looking at the faces of public figures about whom they had heard but never seen. Being a toucher myself, I have always disliked museum rules that prevent people from experiencing sculpture with their hands. Touch is truly my favorite sense. I find that my hands allow me to experience a wealth of delicious impressions and allow me to understand the nature of, say, a rock, a pussy willow, fabric, or a sculpture by directly touching them. I exhibit my work with the specification that it should be touched, because I believe that this is the best way to fully understand it. • Deborah's husband walks into the room with their baby under his arm. The child reaches for her mother. Deborah holds her in her lap as we finish up. • Finally, we find ourselves sitting in Moe's warm kitchen eating homemade pumpkin pie, our last stop before the drive to the airport and home to Santa Fe. We have learned from Moe that she lives a short distance from her mother in order to be able to keep a maternal eye on the twinkle-eyed octogenarian. Some recent events have caused Moe to realize that her mother is getting frail and elderly and that their remaining time together is precious. As a result, Moe has asked us if we will make a cast of their joined hands so that they will always be together. We are more than happy to comply. The two women grip their hands together—one old and worn, the other young and strong and supporting the first. They submerge their gripped hands in the slippery alginate and look into each other's eyes. This is a new adventure for them—different, fun, a bit odd, and deeply meaningful. • The directness and purity of the life-casting process makes it an experiential art form. The process of creating the cast is an essential aspect of the art, not just a means to create a sculptural object. The final purpose of life casting is to penetrate reality deeply and expose its perfection. Life casting may be viewed as a holistic art form, one that not only illuminates and decorates but one that can be used as a healing modality, a means of transforming an individual's concept of self in an intimate way and of documenting relationships between people, while being the catalyst for change in those relationships. Moe and her mother will be holding hands forever.

EXHIBIT OFFERS REAL FEEL FOR ART
by Deborah Kendrick

…Signs that forbid touching at art museums and historical sites—or ropes or chains that have the same intent—have always held, for me, a singular resemblance to the "whites only" signs black Americans once were forced to tolerate. "If you need to touch our art or artifacts in order to appreciate them," such barricades clearly announce, "then we don't want you here." Or, to be more direct: "If you can't see, you don't count".... The PLEASE TOUCH! exhibit by Willa Shalit and Dean Ericson at the Contemporary Arts Center represents the other end of the "who's entitled to appreciate art" spectrum. Not only do the artists *permit* others to touch their work, they *invite* it. • To touch the faces of such personalities as George Bush, Paul Newman, Carly Simon, Jesse Jackson, and others is an intimate exploration of humanity for anyone.... For blind visitors, PLEASE TOUCH! marks an expedition into a wealth of human expression and, for many, the first opportunity for equal access to art.

The Cincinnati Enquirer, Sunday, November 18, 1990

PORTFOLIO

President Nixon's office was on a nondescript floor in the federal building in New York—not where one would expect to find a former president of the United States. The immigration service took up most of the floor, and I could imagine President Nixon riding up the elevator with all kinds of people. Everything about the place gave me the feeling that this man had been abandoned by the world. Even his office door was unmarked.
• When the Secret Service men let us in, there was no activity going on in the offices. It was almost ghostlike. The walls were covered with

RICHARD NIXON

photographs of President Nixon with Brezhnev, Chairman Mao, and other famous people. But when I commented on them, Nixon said that those days were done. • When I entered his office I felt the presence of a great man, and I also sensed his sorrow. I was totally surprised by my reaction, because I had never thought of him as a man before—only as a symbol. But he *is* a human being. • At his direction, everyone left the room. He had agreed to have his face cast, but I don't think he had really thought about it. When I touched him, it felt as if he hadn't been touched in a long time. He drew back at first, and then came forward. • When I removed the mask, I saw in it anguish and pain, on a tragic level. If he had seen that, he would have been shattered. When the photographer came back into the room, President Nixon was holding the mask with great tenderness. The very thing he devoted his life to hiding—his humanness—is what made me appreciate him most. • Some people still have great enmity for this man. What a difficult thing that is for one person to have to bear! If we can have compassion, then we can have dialogue.

JACOB JAVITS OFFICE BUILDING
NEW YORK CITY

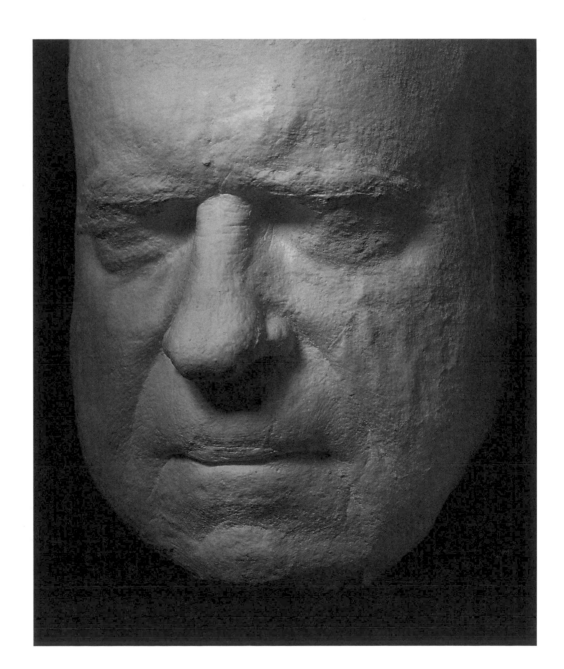

Muhammad Ali greeted me with a warm grin. He spoke softly, his speech a bit blurred; the debilitating Parkinson's disease was just setting in. He was in a jovial mood and laughed with us as we set up the materials. • Applying the oil to his smooth face, I was struck by the gentleness of this man who had made his fortune as a prizefighter. Suddenly, he looked me straight in the eye with piercing sharpness.

MUHAMMAD ALI

"Look over there!" I turned my head quickly. He laughed at his joke. He had reached out with his wit to grab my attention and redirect it completely. Then I understood his strength. It was not only in his body—weaker now—but in his nimble mind. • When his face was completely covered, he called out from inside the mask, "I'm a mummy! I'm a mummy!" Standing up, he staggered around the room. • When he clenched his fist for the arm casting, his hand became a solid ball. His forearm burst with coiled power. • After the casting, he entertained us with magic tricks he was learning. He made objects disappear and told us that through the Power of Allah he could levitate. I watched as he stood erect, concentrating, and I would swear that both his feet rose off the floor. • I'll never know whether or not he really levitated. Perhaps he was able to grip my mind and eye under full control of his own and make me think I was seeing what did not exist. I realized that he is a true magician.

WALDORF ASTORIA HOTEL
NEW YORK CITY

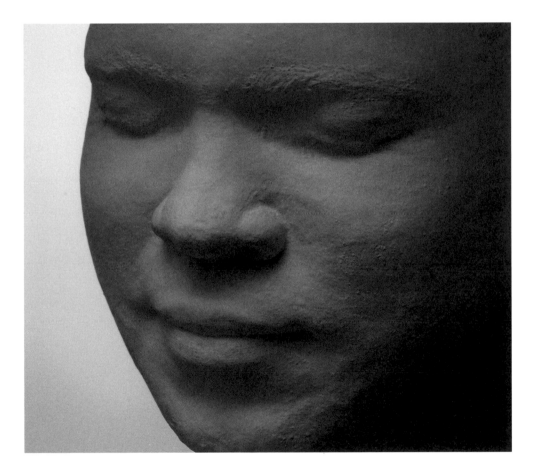

Richard Burton had just performed with Elizabeth Taylor in a play in New York called *Private Lives*, and I noticed that he had a scratch on his forehead from the play. He was charismatic and self-assured. The critics in New York had totally panned the show and had also made cruel personal remarks about him and Elizabeth Taylor. Richard said that he never read reviews and was totally unaware of it. It was a fantastic lesson for me: to just not care, to not read the reviews. • I cast both his face and that

RICHARD BURTON

of Sally, his wife of just six weeks. Sally was very protective of him, and there was a real closeness in their relationship. It was a particular type of closeness; she took care of him in some ways. I think he needed women for that. • Richard had a wonderful face — very sculptural, very rough. I remember quite clearly what he said when I showed him the mask. He exclaimed, "It's terrifying, really. I look like my father. I never thought I looked like him." It was a poignant moment. Then he said, "Everyone's getting face-lifts these days, and someone said to me, 'Why don't you get one?' I said, no, I've bloody well earned this, and I'm going to keep it." • What I did not know then was that Richard was near the end of his life, so my session with him seems very moving to me now. I think the cast was a profound thing for me to contribute to Richard's life. He had never before seen his father's face in his own. • I asked them if they would like to have the two faces mounted separately or together. (It was a wedding gift for them from actress Kathryn Walker.) Richard made it clear that he wanted them mounted together — very close together.

THE GRACE KELLY SUITE, PALACE HOTEL
PHILADELPHIA

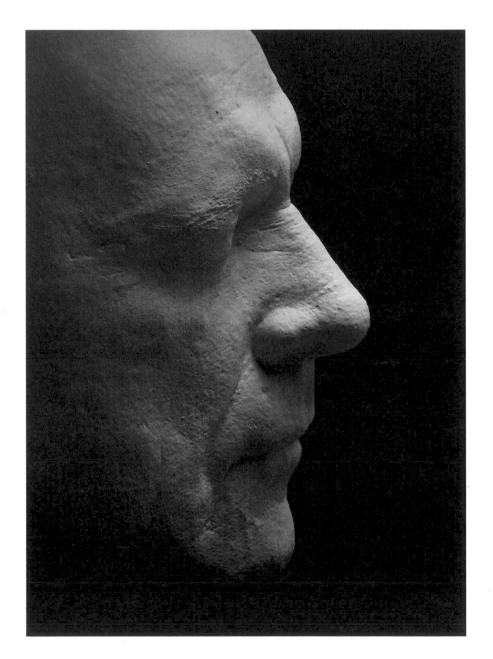

The great film director held court from a brocade chair in his hotel room. He was being interviewed about his most recent film, *And the Ship Sails On*. • This master of character seemed to be peering at all the people in

FEDERICO FELLINI

the room, searching to see who they were underneath the activity they were engaged in. As the interview ended and it was time for me to do my work, he targeted me. He asked why I did this mask-making, seeming mystified by the concept but struggling to comprehend it. • When I touched his forehead, he seemed suddenly to understand. He smiled broadly and looked at me with new eyes, seeming to see me for the first time as he called out my name with a thick Italian accent. "Veela!" he exclaimed. Satisfied that he knew who I was, he settled into the experience. • A few minutes later he gazed at the finished cast and proclaimed with fascination, "Eet ees mystical—how you say—phantasmagoric. Fantastic!"

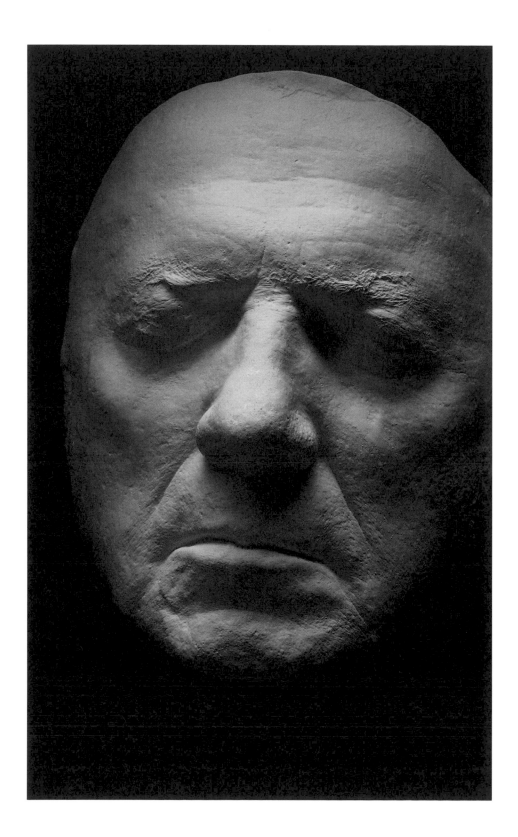

Sophia Loren swept into the rose-filled living room of her hotel suite wearing a floral-print silk dressing gown. Through the window, Central Park looked gray on this damp, chilly fall day. The air was melancholy: Sophia had come to town to be the grand marshal of the Columbus Day Parade, but Cardinal Terence Cooke had passed away and the parade was cancelled. • She had all her makeup on and seemed very regal. She sat down, and I started applying the oil to her face. I felt immediately that she was unaccustomed to having someone touch her face in this way, so I asked if this was unusual for her. She said, yes, she always applies her own makeup. Sophia Loren's makeup is very elaborate: she paints on different eyebrows and changes the

SOPHIA LOREN

shape of her mouth. I understood then that, for Sophia, this was an intimate thing which we were doing. There are many women who almost never are seen without their face made up for public display. In this life casting, the makeup came off; we were literally "going behind the mask." • If she was somewhat reserved and a little distant when I arrived, by the time I left her that day there was a feeling of closeness between us. When I began making the mask, her face had relaxed a bit. Sinking into the process and becoming deeply at peace, she smiled and said, "Ah, it's like a beauty mask." • When she saw the life cast, her earlier reserve completely dropped away and she ceased to be distracted by other concerns. Suddenly she was totally present and mesmerized when she looked inside the illuminated mask. The sight of this intimate portrait seemed to bring her into sharp focus. No longer was she a distant, beautiful actress; rather, she stood next to me as a woman. Tears came to her eyes as she told me softly, "I see there the sincerity, the happiness I feel I project—what I *think* I am projecting—but I must tell you, my happiness is not a 'ha-ha' kind of thing; it is an earthy thing. I see the positive earthiness that is my sense of self." • Her face in the mask is strong, sculptural, androgynous in a way, and very Etruscan-looking. It is not a petite, cute face; it is a striking face with great depth. She saw and liked that depth; it reminded her of who she was.

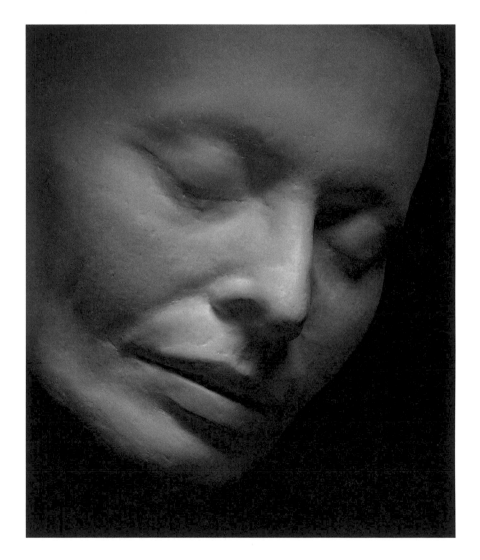

When I entered Natalia Makarova's apartment, I was struck by how richly *Russian* it felt. There were Russian enamel boxes displayed, Russian textiles and furs thrown on a huge, soft couch. This love for the country she chose to leave was moving to me. • Natalia Makarova is *tiny*. I had seen her perform and had felt her huge presence on stage from the audience. It was surprising to see how little her body really is. • We went into the bathroom off the master bedroom to make the castings. Everything here was bright: white tiles, chrome, mirrors. She sat on an upholstered stool in a silky dressing gown with her legs crossed. She held her head high, her long neck extended, as I made the mask of her diminutive face. • Makarova posed for the photographer

NATALIA MAKAROVA

during the mask-making. She moved her wing-like arms in the air and touched the plaster gauze covering her face. In this unusual circumstance, she expressed herself with flair and humor. • I looked at the inner face of the mask with her as soon as it came off. I saw great strength and struggle in it. It showed an artist who had worked hard over the years to perfect her art and to express it with immense power. I asked her, "If you had to choose one word to describe your face, what word would that be?" "Sublime," she replied. • Holding the casting of her petite face, I realized that the session seemed somehow incomplete. I wanted to cast her leg *en pointe*. I applied the gauze and felt the incredibly hard muscles of her calf and the calloused texture of her toes. After several minutes, she started shaking from the exertion but did not ask me to stop. I worked as quickly as I could. I felt the years of development and refinement in those muscles, as well as a determined spirit that insisted on holding it, holding it, even though her body was reaching the final point of endurance. • Finally, I was finished. I removed the mold and looked at the form. Her leg and foot looked like a panther leaping or a fist being thrust through the air. The power and beauty in it were incredible. Makarova appreciated my enthusiasm. "Yes," she commented, almost to herself, "I have the greatest pointe in the history of dance." Then she paused and thought for a moment, and added, almost in a whisper, "But, perhaps, for Pavlova."

HER HOME
NEW YORK CITY

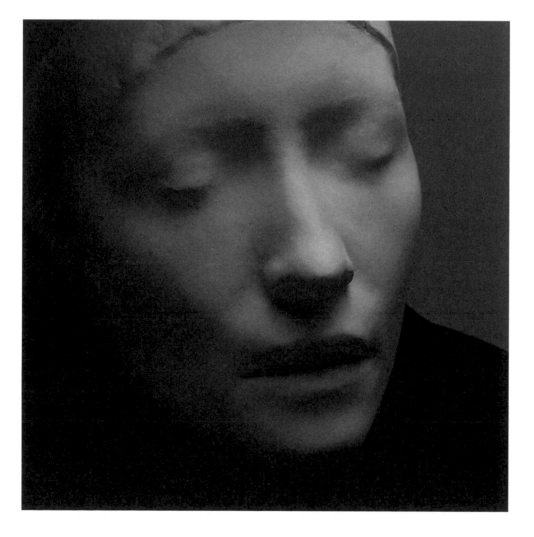

Paul Newman has a sculpturally interesting face, although it is fascinating to see the transformation that occurs when his eyes are closed—his blue eyes are such an important part of who he is. His is a very masculine face that has a feeling of humanitarianism about it. He is a wonderful, down-to-earth man, the type of man who makes one think that if the whole world were made

PAUL NEWMAN

up of people like him it would be in great shape. • He really liked the casting process. He sank into it and relaxed deeply. He was very present—the face shows that—but he was not making a face. I had the feeling that he liked the physical contact as well as the privacy of it. As I started to make the mask, but while he could still talk, he said, "I feel like a mummy," and he made a grotesque face. Then he remarked, "It's tough to hold this for a whole minute." After I took the mask off, not only did he want me to wash his face, but he also wanted me to help him wash his hair. He liked the touching part of the process. • When he looked at his mask, he commented, "Oh my word, it's unnerving, really—I'll be just like that in a few years." I wondered if perhaps he thought that he looked older. Then he said, "That's just how I look when I play dead. That's exactly how I look in my next film. There's the *Terminal Man* for you."

HIS APARTMENT
NEW YORK CITY

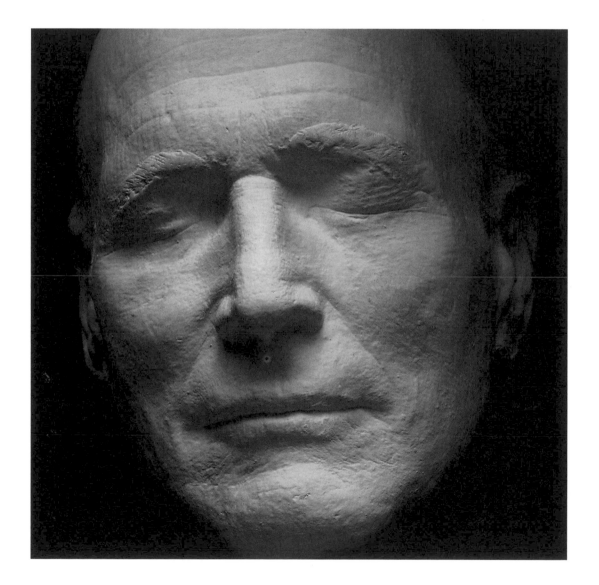

When Sammy Davis, Jr., opened the door to his hotel room, I was struck by the stillness. It was a sharp contrast to the cold air and bright activity on the streets of New York at Christmastime. He moved slowly but with a certain feline grace. Although light on his feet, he seemed to be carrying a great weight on his shoulders, which were slightly stooped. He was slender and short but had a strong presence. On this day the presence emanated lethargy, depression, sadness. His beautiful wife, Altovese, was in the room, very interested in what the mask would look like. A steamer trunk full of videotapes was open in the center of the room. • As Sammy sat down, his chin sank, dropping almost to his chest. He closed his eyes, almost in resignation, as I applied oil to his forehead, cheeks, and chin. I felt that he liked the soft touch and the chance

SAMMY DAVIS, JR.

just to relax and not perform at all. He chose to rest during the process rather than to pose. • As I applied gauze to his features, I looked at the remarkable form of his face. There was great power in his jutting chin, in the straight plane that began at his hairline and continued to the tip of his nose, in his sunken cheeks, and in his protruding lower lip. Unlike some performers whose faces are blank slates on which they can write anything to please the crowd, this face was as strong in its presence and personality as it was different. I gained respect for his courage in presenting himself to the world. As sculpturally odd and somber as the mask looked to me when I removed it and showed it to them, Altovese saw majesty in the image. "He looks just like Mount Rushmore!" she exclaimed. • The face does look as if it is made of stone. I have experienced depression and have lived with family members who were manic-depressive, and I recognized that on this day Sammy was deeply depressed. When I look at that mask, I see a mirror image of the way I feel on my low days. • A copy of this cast hung on my studio wall for several years. One day I went into the studio and found it in pieces on the floor. This is unusual: I am very careful about how I hang the masks. I glued it together and hung it up again. A short time later, it fell down and broke again. I repaired it again. Oddly, this has happened with this mask several more times over the years. I joke that it is self-destructive. Maybe it is just the shape of the plaster.

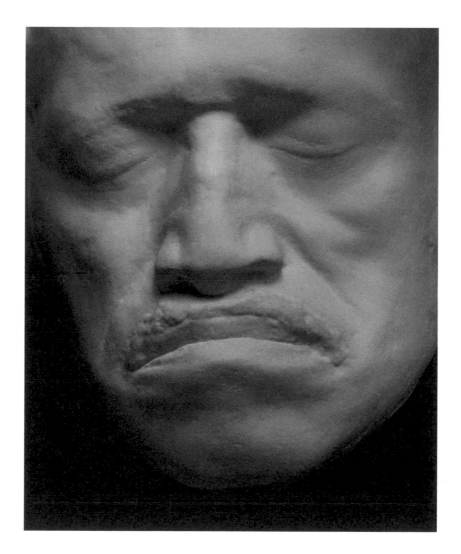

A week before I cast Marcel Marceau's face, I had watched him perform a piece called "The Mask." It is a pantomimed story of a man who puts on a grinning mask. The mask gets stuck; the man begins a futile struggle to remove it, finally lapsing into a state of anguish and despair. It was astounding to watch this performance. Wordlessly, Marceau showed us the grotesquely grinning mask—he created the mask with his own face—and, at the same time, revealed his "true" face behind the mask.

MARCEL MARCEAU

When the character was in the throes of this struggle, I was moved to see a real tear roll down Marcel Marceau's cheek. • The idea of casting someone who has such a profound ability to express, emote, and create with his face was tremendously exciting to me. I arranged a meeting with Monsieur Marceau and went to his hotel after a performance, carrying a small makeup case with my casting materials. • A small, polite, slender, middle-aged Frenchman, the great mime greeted me himself. In the room were several other people who had a Fellini-esque look about them— among them a muscular young man and a woman in fishnet stockings. • I prepared him for the sitting, covered him with a bib, and applied an oil to his face. We began. Finally, I would get to see what face this master of expression would choose! With a mounting feeling of anticipation, I explained to him that because the material set so quickly, he could make any expression he chose: a huge smile, a frown, his famous character Bip. "Non!" Monsieur Marceau interrupted me, "I don't want to create an expression. I want very much to see the face of Marcel Marceau."

MAYFLOWER HOTEL
NEW YORK CITY

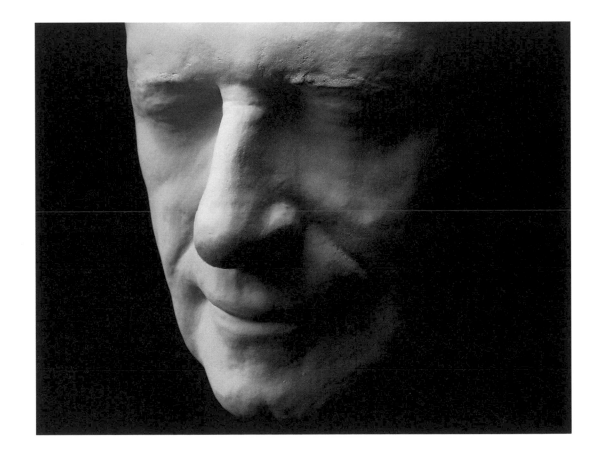

Louise Nevelson's street-level studio was filled with light streaming in through the windows. It is unusual to have that kind of light in New York City, and the illumination on the flat, black surfaces of her sculpture created an otherworldly environment. • Louise Nevelson greeted me with great humor and vitality. I had never before seen her without long thick black false eyelashes and a large scarf tied around her head. Her short silver hair was smooth and shiny, and her eyes burned with life. She wore work clothes: a well-worn, full-length skirt and loose blouse. Her hands moved as

LOUISE NEVELSON

she spoke, waving and pushing the air. I saw nearly a century of creativity in those hands. • Louise addressed me as a young artist. She offered me encouragement. Praising my process, she told me that George Segal had asked her to sit for a casting, but with Parkinson's disease, she could not endure the lengthy process. She told me *not* to have children, saying that they are a waste of time, and that she had known since childhood that she wanted to be an artist. She wondered if I had known. She encouraged me to try new things, remarking that this year, at the age of 85, she was designing her first opera. She was thrilled to have been asked to do it, because she had not been ready for a project like this one before. • Louise sat in a stately manner as I gently touched her face, and she looked with great interest as I showed her the finished mask. We had been talking so intimately that I thought she would be thrilled to see the more spiritual inner face. She closely inspected the object, looking at the rough outer surface and the impeccably nuanced inner face. But ever the architect, Louise exclaimed, "My dear, the outside is infinitely more interesting than the inside!"

HER STUDIO, SPRING STREET
NEW YORK CITY

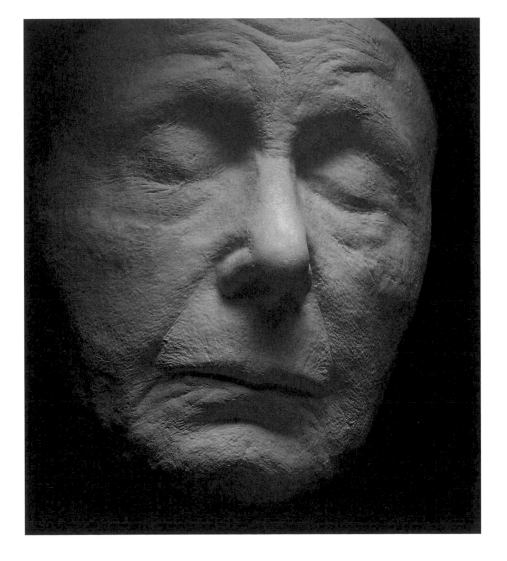

Isaac Stern's studio is a spacious room in his apartment building on the Upper West Side of Manhattan, a few minutes away from Carnegie Hall, the renowned concert hall that he helped to save from destruction. The room had big windows overlooking Central Park, and it felt calm, peaceful, and bright. • Isaac liked the idea that blind people would be able to discover what he looked like, and

ISAAC STERN

he sat down in a jovial mood for the casting, which we did on the bench next to his grand piano. • He smiled broadly throughout the casting, projecting a wonderful expression of mirth and joy. His face has a musical quality to it: there is something harmonious about its shape and a melodiousness in the roundness of the forehead, cheeks, and chin. He was entertained and interested by the experience of the mask-making. It was unique, fun, and something he approached with good humor and confidence. • I removed the mold, and he sat calmly while I washed his face. He showed great pleasure when he saw the mask and held it triumphantly above his head. He had done it! • The mask seemed to hold such a true expression of Isaac Stern's spirit, and as the violin was the vehicle he normally used to express his deepest feelings, I asked him if he would pose for a photograph, somehow holding the mask and his violin at the same time. I was shocked when he said, "No! The violin is real; this is just a mask."

HIS STUDIO
NEW YORK CITY

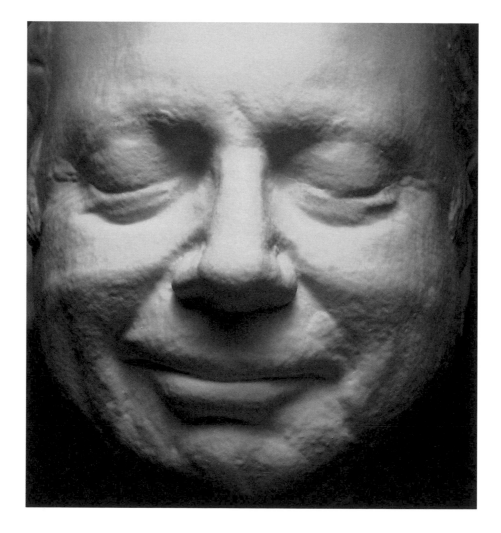

When I arrived at Whoopi Goldberg's dressing room during an HBO taping, the atmosphere was highly pressured and there was a tremendous amount of activity. Stagehands were moving equipment, and I overheard that there were problems with the script, which was in the process of being rewritten and was the subject of a lot of argument. Whoopi herself was the center of all this, clearly the leader, making decisions and telling people what to do. • We waited for Whoopi with her mother,

WHOOPI GOLDBERG

Emma, a robust woman with short hair and a clear, strong presence. It was apparent that she was there to support her daughter, but not in a cloying stage-mother way. The feeling was one of strong camaraderie and a close, respectful relationship. • Whoopi arrived with her personal assistant, Frank Piazza, who exhibited a great affection for her, jokingly calling her "Miss Scarlett." • When the time came to make the mask, there was still a great deal of activity in the dressing room and in the hallway. In addition to the activity of the technical crew, actors including Robin Williams, Billy Crystal, and Richard Dreyfuss darted in and out, joking about the production. • Whoopi sat down and instantly blocked out everything going on around her, miraculously becoming incredibly centered. I tied back her long, thick hair, and a serene smile spread across her face. Her genuineness and strength of spirit were carried from her spirit, through her face, and into the mask. • Hers is the most immediately recognized life cast we have. Her face has a vitality and attractiveness and charisma to it that draws people's attention right away.

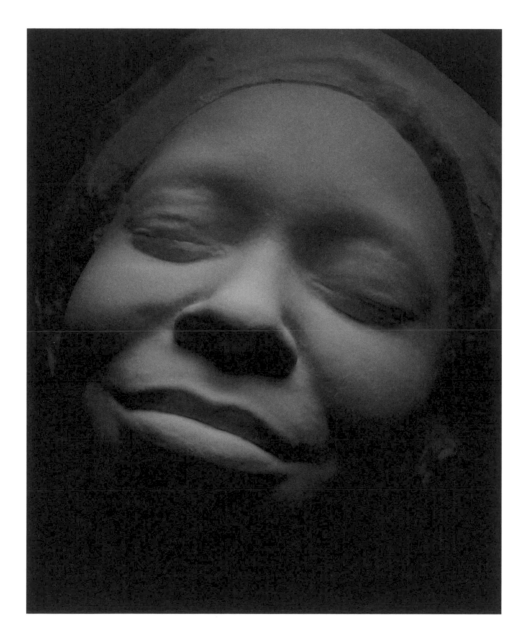

Seiji Ozawa was spending the summer at the Tanglewood Music Festival, conducting the Boston Symphony Orchestra and teaching a master class at "Seranak," the magnificent turn-of-the-century estate of the late conductor Sergei Koussevitzky. I had observed Ozawa's class the day before the casting and was mesmerized by the dancing motion of his arms and hands, which spoke a language of their own, drawing intricate nuances of expression out of the pianist whom he was directing. When a student conducted, the music sounded leaden, but when the pianist's eyes rested on Seiji's movements, the music came alive. Motion was clearly such an important expression of his creativity that I was curious to see what I would find in the

SEIJI OZAWA

stillness of his face casting. • I arrived at his house the following night with my mask kit and my father, who came along to take photos. Two bright-eyed children greeted us at the door and led us through a sparsely but elegantly furnished home to their father, who waited in the living room in a kimono. • Maestro Ozawa sat with perfect posture but without stiffness as I pulled his thick black hair off his forehead. He remained still yet totally alert; I felt that thoughts were dancing in his head. • As I covered his face with gauze, the children pranced around, squealing with delight. They thought this was the funniest thing they had ever seen their father do. There was a great feeling of warmth and respect between these children and their father. Seiji smiled for the mask but held his chin firm. It was a look that contained both enjoyment in the process and a resolution to remain focused till the end. • I removed the mask and wiped off the maestro's face with water the kids brought me in a ceramic bowl. Then I showed him his face. "That face looks just like my father," he said thoughtfully. "I look just like my father. I'm surprised to see that." There was sadness in his voice. I wondered if his father was ill or had just passed away. I also detected a tone, largely unfamiliar in my mask-making experience, that he *liked* the fact that his own face held his father's spirit. Seeing Seiji in the laughing faces of his children, I hoped that they would grow up to feel the same way.

HIS SUMMER HOME
LENOX, MASSACHUSETTS

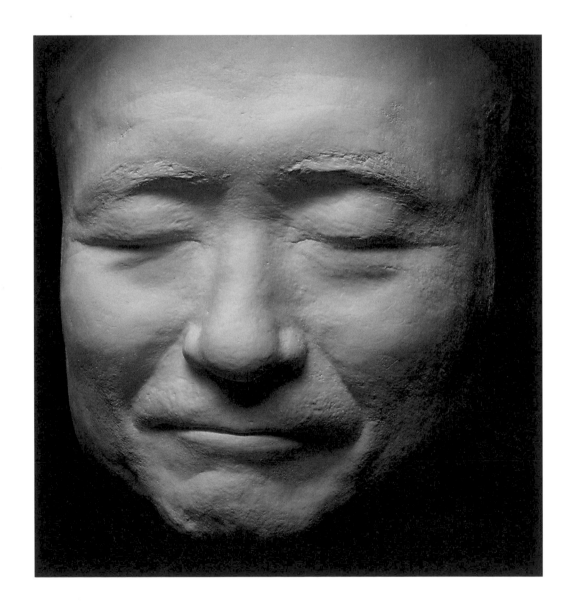

I had held Rosa Parks in high esteem for years before I met her. She seems to me to have been the human catalyst for an immense shift in collective consciousness. When I finally stood in her presence, I was at first bewildered to find that she was a diminutive, quiet, dignified elderly woman with soft gray hair. As a political activist, I was accustomed to the marching-chanting-yelling-screaming sort of protest. • She sat upright in a straight-backed chair, her knees together, and offered me her face. When I touched her, I instantly comprehended a great deal that I had never before understood. I became aware of what it was that she had done in a completely different way by seeing and touching her face and feeling her as a human being. I felt that she was deeply

ROSA PARKS

herself and endlessly present. She seemed to me like a little willow tree that had roots which went 5,000 feet into the ground; you could never move that tree. Rosa Parks has a deep integrity. She does not need to scream and she does not need to yell. All she has to do is stand and remain immovable. • There is power and greatness in her truth. This singular truth homes in with all the intensity of a laser beam. When all the light that she represents is focused, the force becomes powerful and magnetic, as a magnet attracts but also repulses that which is not in harmony with it. Although she is petite and slender and very soft-spoken, Rosa Parks has a giant presence. • The memory of her presence has completely overpowered any details of the sitting. The experience was a revelation for me about how change can occur. The shift that she triggered was massive, and she achieved it simply by sitting in that bus seat and quietly refusing to move. In this brief encounter I learned a whole new way to be. And that is just to *be*. Sometimes you do not have to argue. You do not have to defend yourself. You do not have to fight or hide. You do not have to be afraid or necessarily even react. Just be grounded in your own truths. Her truth is not just a personal one, but one that speaks for all people. As a result of my experience with her, I now really understand the reason that frequently all she says when she is being honored is "Thank you very much." She simply does not need to make long speeches. Her presence is enough.

HOLIDAY INN
DETROIT

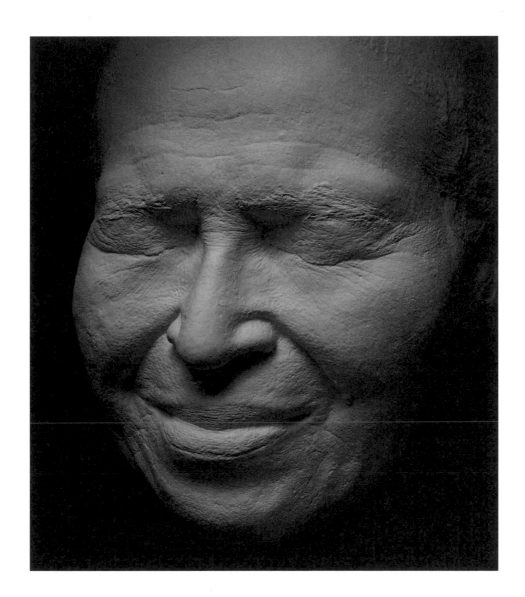

When I entered the White House, the security people searched me in a surprisingly rudimentary way before handing me over to Fred Ryan, the appointments secretary, who escorted me down marble stairs and hallways to the little "Map Room" in the White House. It was a cozy room, and there was an edition of Trollope placed upon a small, round, shiny maple table. About ten men stood in there: Secret Service men, military men, and the presidential physician—all of them waiting for the president with great seriousness. • President Reagan came striding in with a few other men. Unlike his entourage, he was relaxed and jovial, a bright-eyed, healthy-looking man with rosy apple cheeks. • As we got ready to begin, he

RONALD REAGAN

said, "I think I'd be more comfortable if I took my eyes out," and he proceeded to take out his contact lenses. Then he removed his hearing aid. After this, he playfully said, "Well, I took off my contacts and I took out my hearing aid. Did you wonder if I'd stop there?" We laughed. I explained to him that he could create any expression on his face, but he countered, "I'll have my eyes closed. How can I make an expression with my eyes closed?" • He sat quietly as I made the mask. When I removed it and showed him the finished product, he really loved the inside, which he looked at for a long time. He commented, "I thought I was smiling, but I look sad." He also asked me, in jest, if I had been around when they made the Shroud of Turin. Perhaps he saw the spiritual aspect of the mask. He called people from other parts of the White House to come and look at it. • I mentioned to him that two casts had been done of Abraham Lincoln's face: one just before he became president and one after he had been president for four years. The second cast clearly shows how ravaged his face had become. When I cast President Reagan, he had been president for five years. I asked him if he thought the experience of being president had changed or worn *his* face. He looked surprised that I would think of that and answered, "No, I don't think it's affected me at all."

MAP ROOM, THE WHITE HOUSE
WASHINGTON, D.C.

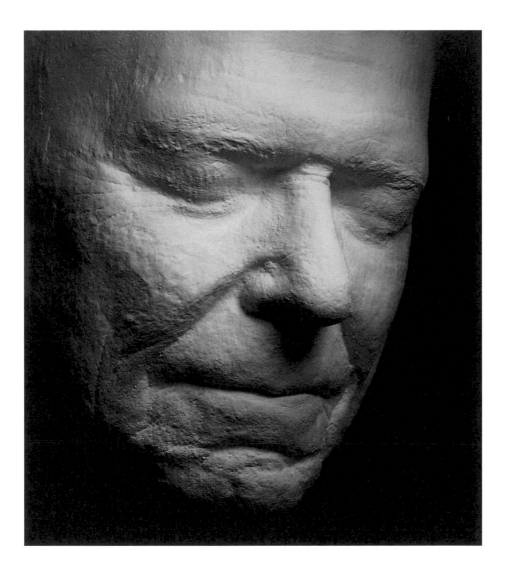

Before I did the casting I was very much aware of Robin Williams's presence. He seems to have a constant, incredibly frenetic, hilarious monologue coming out of his mouth; he's a comic genius with a capital G. You are afraid that he is going to burn himself out. He was talking nonstop when I met him. • He wondered aloud about what it would be like for blind people to touch his face. Would they like what they saw? Did he want them to know what he looked like? Would they appreciate him more or

ROBIN WILLIAMS

less afterward? Did he care? In two minutes he spewed forth a hilarious yet bitingly astute monologue on the issues of "seeing" through touch. • Then, when he sat down to do the mask after the taping of the television show, he became very quiet and withdrawn. It was similar to my experience with Marcel Marceau, another great character actor who had the ability to do anything with his face and to project any kind of expression. Robin just wanted to project an image of himself at rest. He has a beautiful, archetypal jester's face with a long nose. He is not "leading man" handsome nor does he have the face of a bad guy. His face is like an artist's palette containing many colors, and he has the ability to use his face to express anything he chooses. • A strange and rather sad thing happened that night. By the time we had finished making the mask, everyone had gone and Robin had no way to get home. He was the big star, and they had forgotten about him. He asked if we would give him a lift home. He remained very quiet during the whole trip. Robin seemed to be either completely manic or completely withdrawn, and that night I didn't witness any middle ground.

UNIVERSAL AMPHITHEATER
LOS ANGELES

The first thing I did was to make a cast of the clasped hands of Jimmy and Rosalyn Carter. I felt that a strong camaraderie and equal partnership existed between them—a real unity. When I looked at the hand casting later, it was hard to tell who was who, because their hands are about the same size and they were entwined. • The walls of President Carter's office were filled with art: I remember a Robert Rauschenberg painting and a sculpture of guitarist Andrés Segovia's hands. There was also a scroll from the Japanese government, which said, "To Jimmy Carter, a Peace Maker." I

JIMMY CARTER

had a strong feeling of culture and peace and humanitarianism in President Carter's environment and in him as a person. • I told him that he could make any expression that he wanted, and he broke into a huge grin and held it until Rosalyn emphatically said, "No teeth." He clamped his mouth shut and took on a more serious look. • When he looked at the mask afterward, he said softly, "I see an old weatherworn visage there." • He came into the kitchen with me to make the casting. He was very interested in the process and enjoyed helping me pour the plaster into the cast. He told me that he made furniture and liked to work with his hands. • After the casting I had dinner with some friends. Their perception was that it was a very big deal that I had done this and had spent an hour with a president of the United States. To me, however, although it had been a wonderful experience, it was not much different from casting the face of a close friend. Yet by the time I left that dinner party, it was clear that not only did people feel that this was an important thing and that I was a more prestigious person because of it, but it had created a shift in my career, causing my work to be considered more significant.

CARTER PRESIDENTIAL CENTER
ATLANTA, GEORGIA

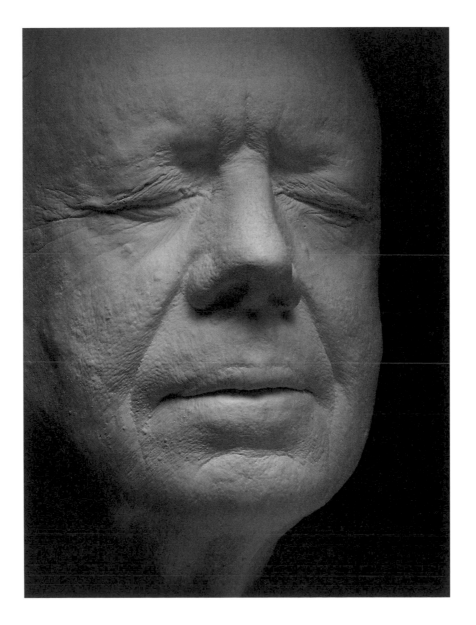

Helen Hayes was 85 years old when I visited her at her rambling mansion overlooking the Hudson River, and she had a great sparkle and vitality. The warmth and worn comfort of her sunny kitchen matched her personality perfectly. The room held a 1940s stove— still in perfect condition—and old print curtains. Everything was soft with age but by no means shabby or even faded. Four pots of

HELEN HAYES

African violets in full bloom sat on the windowsill. • She greeted me and chatted about her recent discovery: she was allergic to the theater! Actually, it was the dust in the theater that had been the cause of decades of illness. She thought it was quite amazing to find, after a lifetime on the stage, that it was her very work environment that had been the culprit. • I set up the materials on the oilcloth covering the round kitchen table. Miss Hayes sat upright, fully intending to project herself as I made the mold. She kept her right hand raised, with the pinky extended in a dainty manner, as I worked. Her face felt as soft and fragile as the face of a baby. I worked very, very gently. • When the mask was done, I lit the inner face. She was fascinated by the image, remarking that it looked more like her than any other image she had ever seen. • As I was leaving, Miss Hayes thanked me, saying, "It felt very good, and the best part was that when you took it off nothing came out!"

HER HOME
NYACK, NEW YORK

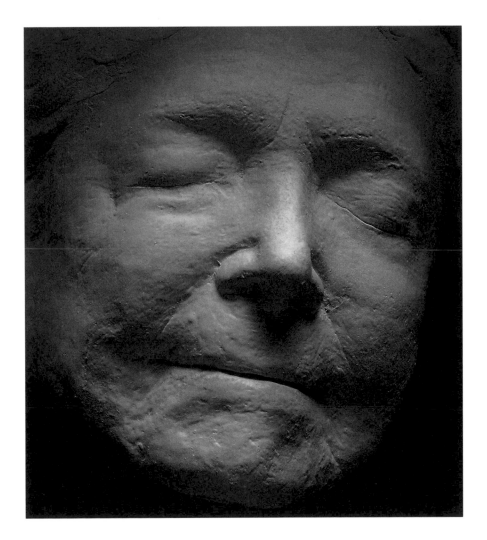

It was 2 a.m., the middle of the workday at Wonderland. I was chatting with Stephanie Andrews, Stevie Wonder's bright, deep—and patient—friend and studio manager. We sat in Steph's area, the studio's central room, which served as an office and waiting room for musicians, record-company executives, friends, and family. • Steve, as his friends know him, was in his back room. This inner sanctum, about eight feet square, had a low couch to the left, where singers or other inner-circle people would sit, a stool on wheels in the middle, and walls lined with keyboards, braille computers, and telephones. Steve would sit perched on the stool, play notes on one keyboard, flip a switch, and the magical sound would come back. Then he would play harmony on another keyboard, take a phone call, sing, or call one of his assistants, saying, "Atiba, will you bring me

STEVIE WONDER

a cup of tea?" in his soft sing-song voice. • A month earlier, I had flown in from New York to talk to Steve about making a mask for an album cover. I had spent three virtually sleepless nights waiting to see him. Steve, a brilliant, kind, generous, creative genius, sometimes can get so wrapped up in his creative process that he can literally keep you waiting for days. When I finally met with him, the encounter was stirring and inspiring. He invited me to work with him and I resolved that I would go ahead, deciding that any inconvenience from having to wait up all night would be completely worthwhile. • I did wait up many nights for, and with, Steve. I cast his face several times, as well as those of his family, friends, children, and band members. Wherever he was—being driven in his limo, in a hotel room, in his studio—he was surrounded by his music. Creations in progress swirled around him every moment. • Steve did not want dark glasses added to his mask on the album cover. The rumor was that Motown preferred that he appear in public only with his dark glasses on, but he wanted to show his face to the world uncovered. • Now, at 2 a.m., Steve called me into his room. That morning I had made a cast of Mumtaz, his youngest son. Two-year-old Mumtaz had sat bravely as I covered his face with plaster gauze. Steve greeted me: "What's happening, Willa?" I knelt in front of him, reached for his hands, and placed them on the plaster cast of his child's face. Steve beamed . "He looks like me," he proclaimed. "This boy looks just like me!"

WONDERLAND STUDIOS
LOS ANGELES

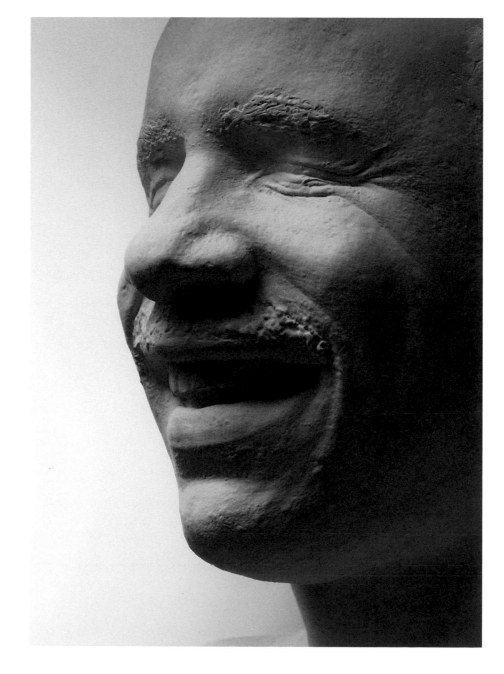

Dean and I had been working with the Ailey company for more than two years when we finally had the chance to cast Alvin Ailey himself. Rumors had been circulating for months that he was ill, but there was still a pervasive feeling that he was immortal. • Perhaps Alvin was thinking of his own mortality when he agreed to do the cast. The company was surprised that he was doing it. They knew how tremendously busy he was and did not think that he would take a break to do something like this. But in fact the contrary was true: not only was he excited about the prospect of having his face cast, but from the time we entered his office, he offered endless ideas on who else we should cast. He urged us to cast stunning Judith Jamison, the emerging star Desmond Richardson, and other important figures in the world of dance: Martha

ALVIN AILEY

Graham, Katherine Dunham, Tally Beatty. He offered to make contacts for us, to help us set up meetings with these people. • He sat in a black upholstered high-backed chair behind his huge desk, preparing for the casting. At the last moment before we began, he reached out and picked up an African carved ebony head from his desk. "Isn't this a beautiful face?" he asked. We agreed. • The beauty of the carved face was nothing, though, compared to the beauty of Alvin's face. I had greatly admired his work for my entire adult life. For two years I had been intimately involved with his dancers and had learned of the depth of their commitment to him and to his vision. I had felt with my own hands the magnificent bodies of these dancers who had moved for years under his direction. As I put oil in his curly beard, I was profoundly impressed by the strength and majesty of his face. I glanced up at the wall and saw an old poster showing Alvin as a young dancer, bare-chested, pantherlike. Now he seemed more like a lion, definitely a king. • As we made the mask, Alvin sat in a regal posture, his chin jutting forward. He focused intensely and profoundly, every ounce of his essence summoned up and poured into the mask. • When he looked at it, he was clearly moved. "Are you ever in California," he asked? "I'd love it if you could do one of these of my mother. And if you do, maybe you could bring along one of my face to give to her." • Six months later, in December 1989, Alvin Ailey died.

ALVIN AILEY AMERICAN DANCE THEATER HEADQUARTERS
NEW YORK CITY

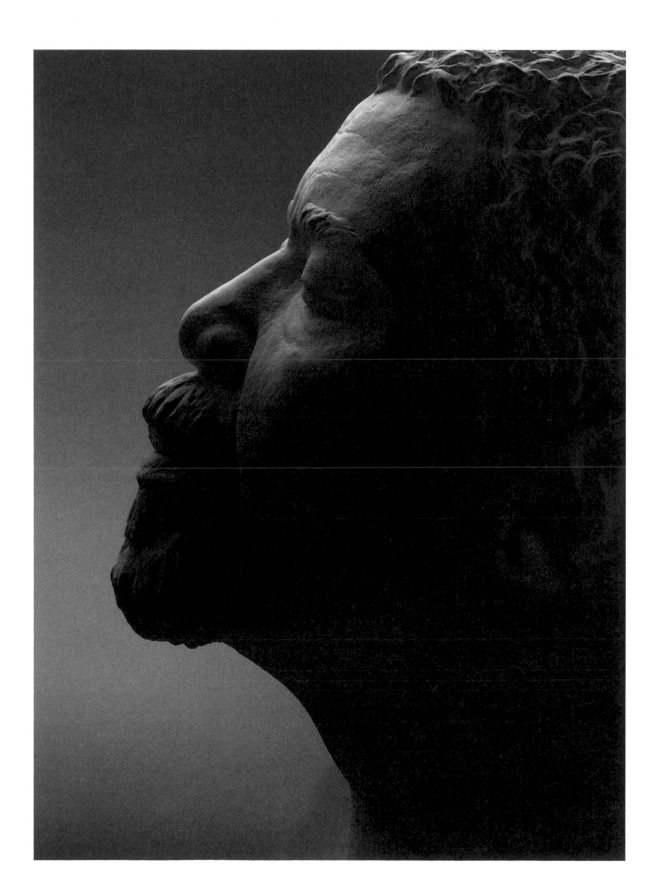

Waiting in the exquisitely appointed lobby of the Plaza Athenée Hotel, I remembered that the last time I had been there was to see Olivia de Havilland. Somehow the refinement of the décor seemed more suited to her than to "cowboy/outlaw" Clint Eastwood. As I sat in the Queen Anne chair, sipping Perrier and waiting to be called up to his room, I realized that I wanted to do more than just a face: the neck and shoulders would add a lot, I thought. I wondered if he would agree to take his shirt off for me. • Clint was in New York for the opening of *Bird*, a film he had produced and directed about jazz immortal Charlie "Bird" Parker.

CLINT EASTWOOD

Another departure. Artistically, Clint Eastwood was saying to the world that he had deeper creative sensibilities than he had perhaps revealed before. A new picture of the man was beginning to form in my mind. • His assistant, Marco Barla, came down to get us and told us on the elevator ride up that he had been with Clint for twelve years. Another unexpected discovery. "The Man with No Name" was a loner. Eastwood was not. I was about to meet someone very different from the personas that made him famous. Still, when we were setting up in preparation for the casting, while Clint was still in the other room, and we could not move the heavy television console that was in our way, Marco told us, admiringly, "Don't worry. Clint will move it when he gets here." And sure enough, he did. • At my request he removed his shirt and then sat down to be immortalized. He was very cooperative and really paid attention to the casting process. He was not relaxed, but instead concentrated on creating an expression. The serious look he projected was more akin to Dirty Harry than to the gentle man who loves jazz and is kind and friendly to those around him. • I see a strength and masculinity in the form of his face, but there is also a real sculptural delicacy and sensitivity there, too. The complex form of Clint Eastwood's face reveals to me a truly multifaceted person.

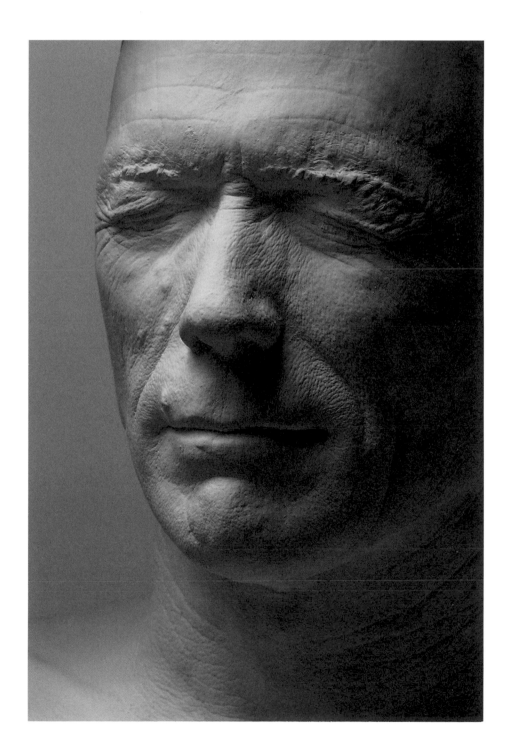

It took three years to set up a casting of this man whose face is such a powerful image that it is banned in his Tibetan homeland by the Chinese government. • When we arrived at the Buddhist Learning Center, there were hundreds of people waiting to see the Dalai Lama, and I realized that His Holiness does not just float around giving benedictions to people; he is a very busy man. Dean and I waited in the living room of the apartment while His Holiness finished up a videotaping next door. The monks who kept us company were delightful. They had shaved heads, sparkling eyes, and wore maroon robes. Smiling cheerfully, they seemed to have simultaneously a great depth of spirit and a childlike lightness.

THE DALAI LAMA

• At the appointed moment, the Dalai Lama walked into the room, spoke to the monks in Tibetan, and greeted us. He sat down, removed his glasses, and immediately looked very serious. Afterward I found out that he is very rarely touched by men, and never by women. During the casting, I had a feeling of great humility rather than the sense of pride I had expected. • When I took off the mask, I noticed that the inside of the mold was stained with the yellow saffron that is applied to the Dalai Lama's head in the morning. It was very poignant to me that I was holding something in my hands that had been in direct contact with this holy man. The face in front of me was shockingly powerful, and it seemed full of human concern. • His Holiness looked at the illuminated inside image, laughing brightly, and then it was time for him to go to his next audience while we poured the plaster. When the monks saw the mask, they immediately remarked, "That's what His Holiness looks like in meditation." And indeed, when the Dalai Lama came back to look at the cast, he broke into gales of laughter, confirming, "That's what I look like in meditation. Yes, that's me." He thought the mask was delightful, but he did not seem to be intrigued with the image of his face; it is not where his identity lies.

THE BUDDHIST LEARNING CENTER
WASHINGTON, NEW JERSEY

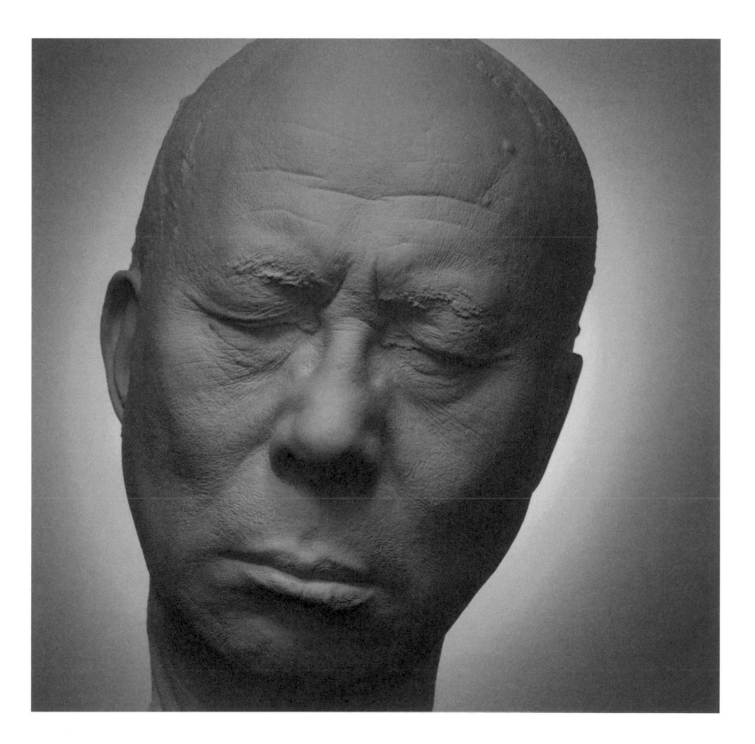

Branford Marsalis is on the road constantly, hopping around from city to city, so it took me several months to set up this casting for the "New Orleans' Own" project for the Lighthouse for the Blind. Finally, I found out that Branford was going to be in Los Angeles with an hour to spare, so I flew in to cast him, arriving at his hotel at 11:30 a.m. • Roderick Ward, the young, vibrant, dreadlocked artist/road manager, met me in the lobby and brought me up to Branford's room.

BRANFORD MARSALIS

Branford was just getting up and came into the room in a T-shirt and sweats. He is one year older than his brother Wynton and, on this day, was much more solemn. • After we said hello, he took a couple of phone calls to discuss appointments and schedules. I asked if he would take off his shirt for the mask—I wanted to cast his broad shoulders, too. He agreed and sat down. As we began, his face became a little sad, so I told him that he could think about something pleasant. He did not change his expression but instead emoted a kind of sadness and vulnerability. When I touched him, I felt him relax deeply inside. As I was putting oil on his face, I said, "You have your brother's ears." He replied, "No, my brother has my ears. Actually, we both have my father's ears." Wynton and Branford do not look alike at all, but they do have the same ears. It was great to see the Marsalis ears on his head. • To me, Branford's face is poignant in its depth and strength and in its sensitivity and melancholy.

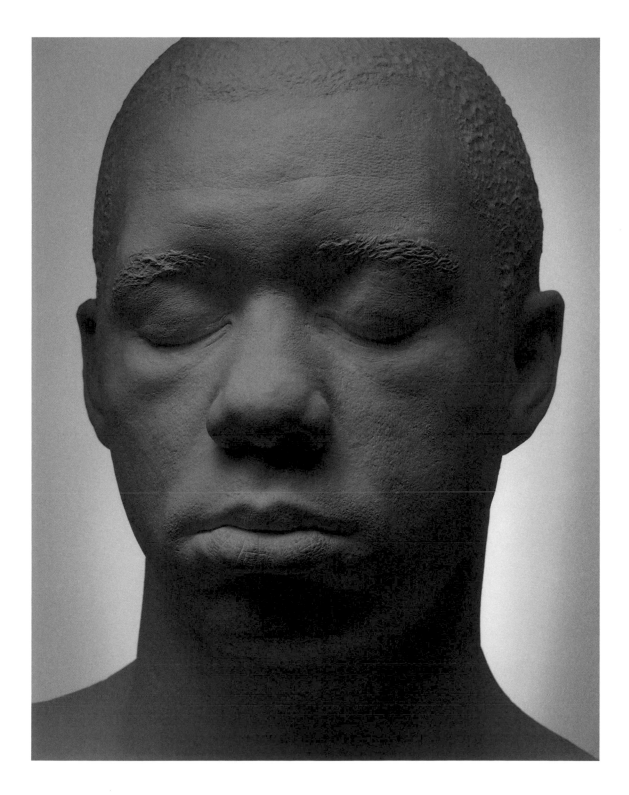

Wynton Marsalis did not show up at the scheduled time on Friday. I waited an hour, two hours. Dave Robinson, his road manager, suggested I come back on Saturday. • The next day, I waited outside the rehearsal room as the musicians arrived. Wynton came up to me and apologized profusely for "dis-ing" me (disrespecting me). He explained that he had locked himself out of his apartment the previous day. He looked deeply into my eyes and leaned into me until I was backed up against the wall. There was a friendly quality about him, so it was not upsetting; it seemed to be

WYNTON MARSALIS

his way of making direct contact between us. • He was rehearsing about twenty musicians for a performance in the "Classical Jazz" concert series at Lincoln Center in New York. During the rehearsal, I remember Wynton sitting at the piano, discussing the order of the all-Ellington program. He wanted to change the sequence because he felt that Duke Ellington would not have put the songs in that order. It was clear that he understood not only the music of Duke Ellington but the consciousness of the man as well. • Rehearsal ended. Everyone else left, and I set up in the chorus room amid the music stands and instruments. I started making the mask, and a beautiful smile came over Wynton's face. It was an internal smile, not one directed at me; he was in a place where he was happy. When I showed him the mask, his reaction was, "Wow, I look like a cherub or something." He seemed a little embarrassed that he looked cherubic rather than cool or hip. • I asked him if he would like to have a copy of the cast, and he told me that he wanted to send one to his best friend, the blind jazz pianist Marcus Roberts. He wanted Marcus to know what he looked like.

CHORUS REHEARSAL ROOM, AVERY FISHER HALL, LINCOLN CENTER
NEW YORK CITY

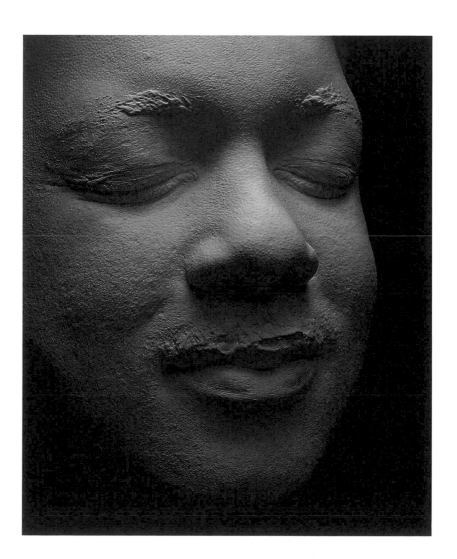

Scott Momaday arrived at twilight with a friend. He wore dark glasses, black cowboy boots, gray wool pants, and a blue soft cotton work shirt. He strode in and looked around at all the faces mounted on our walls. He seemed to be absorbing their forms, digesting them, filing them. When it came time for the casting, he nodded that he was ready. • Scott sat in our casting chair, a 1950s hospital gurney. I asked him if he wanted to leave his turquoise nugget necklace on. "Shall I?" he asked. He decided to keep it on. I was glad, because I knew that the necklace would intrigue people who saw the cast and remind them of his Native American heritage. • I pushed back his silver-and-black shoulder-length hair and applied oil to his face. He held himself proudly. What a magnificent face! It had a universality about it. In it, I

N. Scott Momaday

saw a human being who made me proud to be a member of the human race. The physical form of his face seemed to indicate that he was the vessel for a body of great knowledge, but he did not wear that knowledge as an ornament. I saw that his face was one of great kindness and generosity but one that could also be stern and terrifying. • As we took the mask off, Scott remarked, laughing, "It felt like I was being wrapped like a mummy—marvelous!" He looked at the inner image with great intensity, as if determined to identify what it was that he was seeing and feeling about it. "Wow! I recognize myself," he exclaimed, and hearing himself say that, he laughed again, a little embarrassed. "I certainly wasn't smiling," he added. But then he remarked that this was his private smile rather than the one the outside world usually associated with him. "Some people can put on a good fake smile. I can't," he commented. • The casting session was finished, but I felt that he was reluctant to leave. He kept looking over to the corner of the studio where the mask lay, waiting to be cast. I asked him if he wanted to see his face one more time before he left, and he admitted that he did. He looked at it for a long time, deep in thought. When I asked him if he saw something about himself in the mask that he had not known before, he said, "Yes, definitely." Then he paused, searching his mind deeply for a description, and finally said, thoughtfully, "But I just don't know what it is yet."

OUR STUDIO, COLLEGE OF SANTA FE
SANTA FE, NEW MEXICO

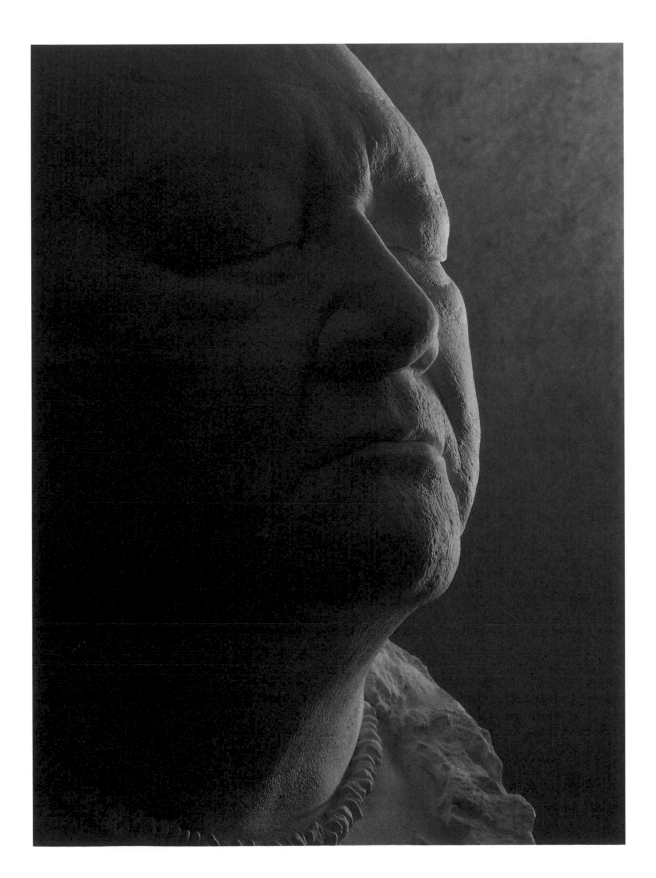

As her companion, Fisher Stevens, smiled, chatted, and asked questions, Michelle quietly stalked around the studio, catlike, peering at all the faces. Wearing no makeup and dressed in jeans, she carried herself with

MICHELLE PFEIFFER

a quiet, unassuming grace. • Fisher watched as we made Michelle's mask, and then Michelle looked on as we cast the smiling, jesterlike face of Fisher. Each exclaimed over the character they saw in the other's face—an appreciation that overflowed with love as the inner portraits were illuminated. • Life casting, by its nature, shows the stark truth of a person's face. It is not a portrait form that plays up the cultural convention of attractiveness. Michelle embraced this raw image of herself. She told us that when she first saw our work, she fell in love with the imagery of the "mask" and what was behind it. She valued the essential feeling and mood that we captured in her face.

OUR STUDIO, COLLEGE OF SANTA FE
SANTA FE, NEW MEXICO

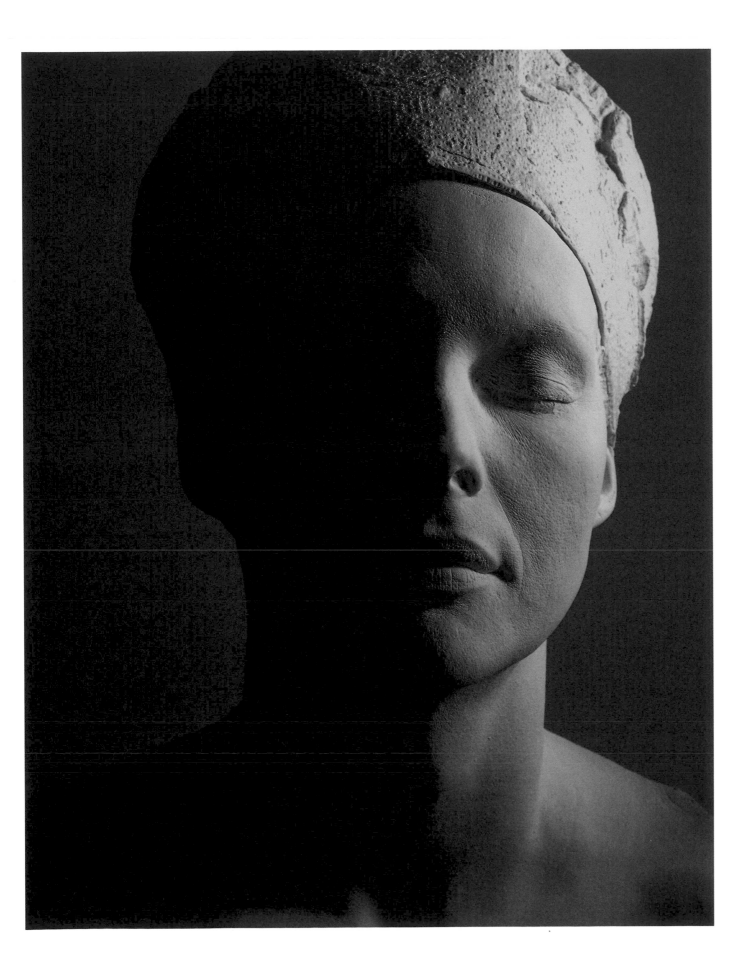

When Dean and I arrived at MacDill Air Force Base, we were jolted by the shrieks of military jets taking off in tandem. The Gulf War had just ended, and I had an intense flash of what it must have been like to be under air attack. Being a pacifist, I had mixed feelings about meeting General Schwarzkopf. • We had a military escort to the building where CentCom is housed. There, we were searched and brought up to the general's offices. The general's support staff were all extremely congenial and relaxed. Everybody seemed pleased that I was going to immortalize General Schwarzkopf's face. It was clear that they looked upon him with great respect and affection. • Our escort, Public Affairs Officer Captain Cathy LoPresti, told us a story while we waited. When

H. NORMAN SCHWARZKOPF

General Norman "The Bear" Schwarzkopf came back from the war, there were crowds to meet him, many of whom were waving bears. He paused in the crowd in front of a mother and her little boy, who was holding a teddy bear. He asked, "Is that bear for me?" and took it from the boy. Later, watching this scene on videotape, he saw that when he took the bear the little boy's face fell. He realized that he had taken the boy's personal teddy bear. Cathy was able to locate the family, and the general gave the boy's teddy bear back to him. • We set up our casting materials in the washroom adjoining the general's office. General Schwarzkopf entered, beaming. He is a huge, charismatic man who exudes warmth, exuberance, and strength. I was surprised to feel totally at home. • After we finished the mask, the general shared with us that when he agreed to do the mask for the permanent "touch" installation of bronze faces at the Gift Gardens of Palm City, Florida, he had thought about what it would be like to lose *his* eyesight. He had considered what might be the last image he would wish to see, wondering if, being a nature lover, he would choose to look at a beautiful landscape. But no, he realized that he would want to see his son playing with his dog. He explained, "It's not that I don't love my wife and my daughter, too, but there's something special about my son right now. He's at that magical point between being a boy and a man. Whenever I want to have that warm feeling inside, all I have to do is think about my son."

U.S. CENTRAL COMMAND HEADQUARTERS, MACDILL AIR FORCE BASE
TAMPA, FLORIDA

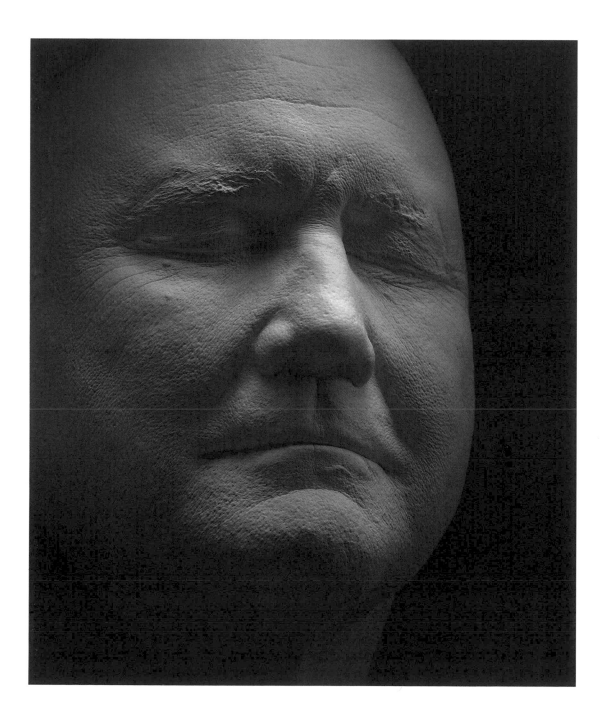

When I first spoke to Amy Tan about casting her face, she told me that she was very interested in masks but was nervous about the process. She questioned me as to what it would be like and asked if it would be OK if she had a friend along for moral support. By the end of our conversation she was reassured and agreed to the casting. • Her house in San Francisco is very beautiful, all subtle shades of jade green and with a lot of Asian art. Amy took us to the comfortable kitchen on the second floor to meet her friend and her husband, Lou De Mattei. • Amy told us that she had been to the eye doctor that week and had looked through lenses that allowed her to see her face as others see it, not as reversed by a mirror. She

AMY TAN

was surprised to see how asymmetrical her face is. Her face *is* very asymmetrical— it swings wonderfully off to one side. As she steeled herself for the sitting, I realized that she'd thought about it a lot and in preparation for the experience had begun to see her own face in a new way. • In all the pictures I had seen of Amy Tan, her black hair completely engulfs her little face. As I was tying her hair back, I noticed that she had wonderful little curly ears, so I asked her if it would be OK to cast them. She replied that her mother had always told her that she has lucky ears, and she said it would be fine to cast them. • During the mask-making process I was struck by the way the white plaster transformed Amy's normally dark appearance. There was a feeling of illumination rather than shadow. When we shone the light into the mask, she just giggled and said, "I look like a moon lady." • Her husband also loved the mask. I've witnessed this personal moment before: when a loved one's face with closed eyes is a familiar and intimate image for the person who has slept next to them and who has perhaps kissed the closed lids, they are reminded of their feelings when they see this image in a mask. I think Amy's husband experienced that, and it was wonderful to see this special expression of love. I asked her if she thought the face looked like that of her mother or anybody else she knew, and her husband chimed in, "No, that doesn't look like anyone else—that's Amy."

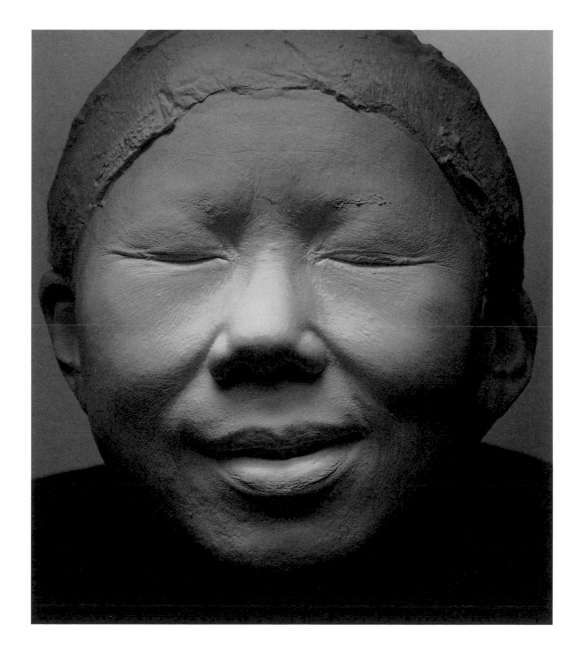

Our friend Charles Barnett had just made a video of Dr. Teller softly crooning a fairy tale that he had sung to his children many years ago. He was struck by the humanness of this man, who was revered by some and called "Dr. Strangelove" by others, and suggested that we create a cast of his face. • On the appointed day, Dean and I waited for Dr. Teller in the nondescript lobby of the Los Alamos Inn. He walked in, accompanied by a young scientist from Los Alamos National Laboratory. Our subject was of medium height, a stooped old man with a faltering walk, leaning heavily on a beautifully carved wooden staff. He had thinning silver hair and huge, bushy, gray-and-white eyebrows. He looked like

Dr. Edward Teller

an ancient, wizened magician. • We walked together to his room and set up. While we prepared the casting materials, I was surprised to hear the scientist present a "Star Wars" budget to Dr. Teller that detailed a strategy to obtain millions of dollars in funding for SDI. • When we indicated that we were ready, Dr. Teller lowered himself into a soft chair. He was very interested in who else we had cast. He had never heard of Richard Burton or Stevie Wonder. When we mentioned violinist Isaac Stern, he said, "Now that's a great honor." • As I touched the great scientist's face, I felt his age deeply. He had shaven haphazardly—he was clearly not interested in the boring details of grooming— and there were patches of stubble that he had missed with the razor. I had the distinct impression that his inner world was of much greater importance to him than his outer appearance or even the outer world. • When we removed the mold, he remarked drily that "the best thing about it was when it was over" and joked about what an ordeal it had been. But it was clear that he was pleased and that he found it to be an intriguing experience. When we illuminated the detailed concave surface of the mask, he peered at his own image and gave a little hawk-cry of horror, exclaiming, "Acchh, the anti-Teller!"

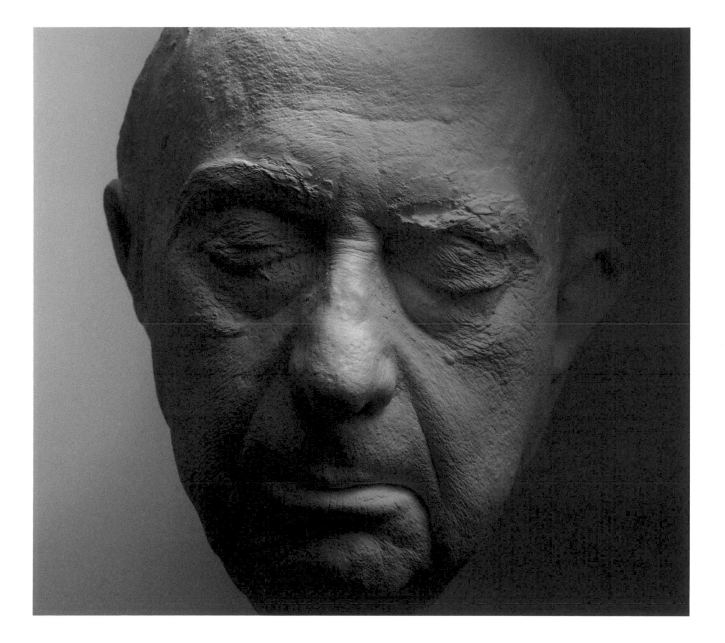

The Atlanta Braves, Ted Turner's baseball team, were two games down in their first World Series. The entire city was abuzz in anticipation of the games that would be played at home the next three nights. • Dean and I announced our arrival at the media magnate's outer office. The walls were covered with scores of awards given to Ted Turner, articles about him, photos of him. The level and diversity of this one man's

TED TURNER

achievements were astounding. Entrepreneur, innovator, yachtsman, environmentalist. I looked forward to seeing the contours of this Renaissance man who not only dabbled but excelled in so many arenas. • We walked into the executive conference room to set up. David Frost had just completed an hour-long interview with Turner, and the crew was breaking down. Technicians wheeled lights and cameras across the deep green carpet. • When we were totally prepared, we invited him in. We explained the process and began. It was clear that this was not a day for relaxed and informal chitchat. When I suggested that he focus his thoughts on four straight wins for the Braves, he smiled wryly before his features disappeared beneath the alginate. • Ted Turner concentrated during the mask-making and got up quickly when we were finished to look at his face. The inside of the mask revealed sharp, chiseled features, fixed with great intensity. Turner looked at himself, smiled, nodded in approval, thanked us, and strode out to his next adventure.

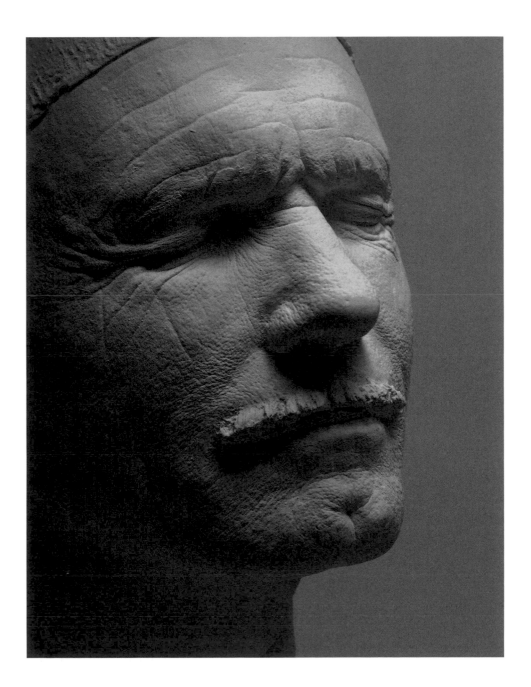

A crowd waited outside the Blue Note on Seventh Avenue. The month-long seventy-fifth birthday celebration for Dizzy Gillespie was in its final week, and tonight's concert featuring Dizzy with trumpeters Red Rodney and Wynton Marsalis had been sold out for weeks. Dean and I edged through the crowd and into the club to find the smoke-filled bar jammed with people lucky enough to get in, milling around in anticipation. • We slipped upstairs to the tiny dressing room and found Dizzy inside,

DIZZY GILLESPIE

wearing a black cowboy hat, a beige suit, a black-and-white spotted shirt, and a gold pinky ring. There was a softness about him—in spirit and body—as he held his trumpet, touching it, inspecting it closely. His face, intensely animated when he smiled or played his trumpet, was limp now, like a deflated balloon. • He seemed exhausted from the grueling month of performances and media attention. We knew we had only a few minutes to capture our image, and we hoped Dizzy would come to life. Suddenly, Dizzy's niece and nephew entered the room, and he broke into a huge grin. Great! We invited them to stay and watch, silently willing that he'd keep smiling. • As we began applying the alginate, Dizzy unexpectedly puffed out his cheeks in his inimitable way and held them as we worked quickly to capture that immortal image. We thanked Dizzy and asked him how he could hold his cheeks in that position for seven whole minutes. • "Well," he remarked with an impish glimmer in his eye, "it will take the blind people quite a few minutes to get a feel for the whole face, so I thought I'd put a few minutes into it for them."

THE BLUE NOTE CLUB
NEW YORK CITY

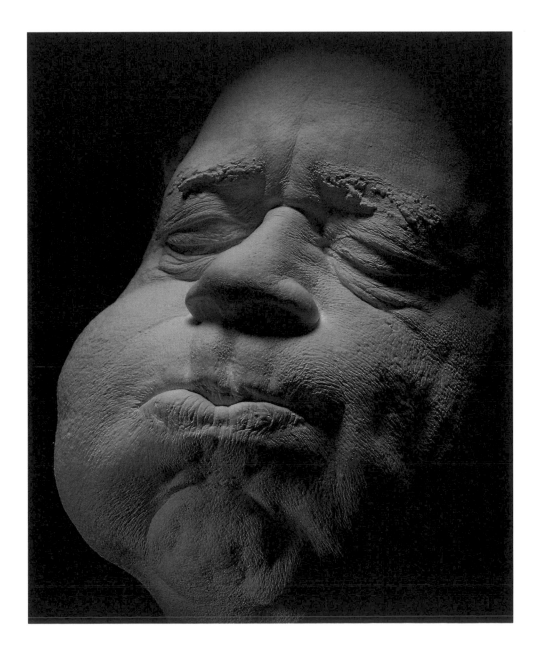

The casting was done at 9 a.m., and even though Sting had performed the night before at the Los Angeles Forum, he had already played a game of tennis and was sitting drinking orange juice when I arrived. There was a feeling of health and business about him. It struck me that he was a good example of the new kind of healthy rock star, the polar opposite of people like Jimi Hendrix and Janis Joplin, whose music I had grown up with. Sting's longtime companion, Trudy Styler, was there, and I showed them a portfolio of my work. • Sting was intrigued by it. Sometimes the life/death aspect of the masks fascinates people. There is a long tradition of death masks in European cultures, and even life masks are sometimes associated with death. One can easily imagine that at the moment the spirit leaves the body, one could look back and see the face looking just this way — literally an out-of-body experience. Rather than being put off by this, Sting was attracted to it. • As I draped a paper bib over him, tied his hair back, and applied a light oil to his face, I looked closely at Sting's face. I noticed its youth—there was not much etched into it yet. Sting seems to be an explorer and a seeker. When someone is committed to learning, you see in the face the information-gathering process rather than the look of a finished human being. • I made two masks that day, one for me and one for him. I chose to make

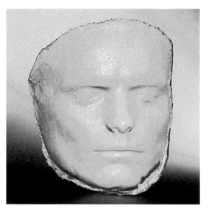

a plaster gauze mask, using a special plaster that is safe to apply to the face. Although the alginate masks have greater detail, the simplicity of the plaster gauze technique has great appeal. During the first mask as I dipped plaster gauze in warm water and applied it to his face, carefully going around his nostrils so he could breathe, Sting focused hard on producing the "Sting performance face." • I held the mold of Sting's face in my hand. Shining a light into the concave, inner surface of the mask produces a startling illusion. The impression seems to be a three-dimensional positive, rather than a negative, and like a hologram, it seems to float in air. I call this the "inner face," since it appears when I light the inside of the mask and shows an image of the person inside themselves. Sting and Trudy were both fascinated when they looked at the illuminated face. • After we had finished the first mask, Sting asked me if I could make the second mask a death mask and cast him lying down. I had never made a mask this way, because the flesh falls back when one lies down and the character is not as strongly shown. But I agreed to do it. Perhaps Sting wanted to mimic the lifelike statues of nobles that one sees lying on top of tombs in old churches in England and Europe. It seemed a very gothic thing for him to want to do. • Afterward, I showed him both masks. I was not surprised that Sting preferred the second one.

CHATEAU MARMONT HOTEL
LOS ANGELES

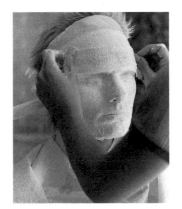

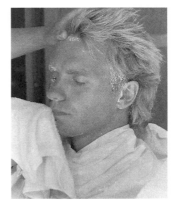

Every minute of Arnold Schwarzenegger's day is tightly scheduled; he uses his time carefully. When we met, he was in Santa Fe shooting *Twins*. Dean and I went to his hotel room with all our materials and set everything up. We wanted the casting to go quickly and smoothly. • Schwarzenegger entered the room, smiling and energetic. He was extremely interested in the process and asked us questions about the materials we had and what we were going to do. He seemed really excited about the prospect of being cast. We also felt a level of excitement similar to what we experienced when we worked with other world-class athletes and dancers. There is a strong sense of collaboration: the models come with physiques that they have attained through years of hard work, and Dean and I arrive with years of experience in capturing the physical form. • Dean told him that we could make the cast very fast—in about ten minutes or so. He said, "Oh, but I've never held a flex for longer than ninety seconds." This meant we had to work fast to try to capture it. I knew that he was a great athlete and that this wasn't any weakness on his part; it was just another boundary defining our work, if we truly did want to capture the human body in motion. • We had a great time doing the casting. There was a feeling of play and adventure. Arnold concentrated exuberantly on the process. He is a man of great strength—mental and physical. We worked quickly and precisely, and we all laughed a lot. • Arnold Schwarzenegger is an important part of the "Please Touch!" collection.

His immense appeal is a bridge to reach many people who might not otherwise appreciate art. Not only did Arnold contribute his bicep, he also contributed his aura.

• • •

Carly Simon's rambling Upper West Side apartment felt feminine and elegant yet homey. We sat in the kitchen sipping tea as I described the mask-making process. I looked at her face and wondered which of the many aspects of her the mask would pick up. I felt a tentativeness in her manner, a bit of timidity, but also a great female strength and vitality. I saw the importance of her mane of hair in her look and remembered that as a child she had been considered the funny-looking one of three sisters. Now she is considered a great beauty. • I followed her into her bedroom, where she sat and relaxed in an upholstered chair set in the corner, a fringed lamp beside her. As I began laying on the plaster gauze, her face took on a serious, introspective look. She withdrew into herself, and if she was projecting anything at all, it was seriousness. When half of her face was covered, her two young children suddenly bounded into the room. They climbed into her lap, whispered "We love you!" into her ear, giggled, and held her hands. They thought this mask-making was really funny. • Carly broke into a huge smile that transformed her face completely. It came alive, radiating exuberance, love, and humor. Luckily, her bathroom was right there, and we were able to use a toothbrush to remove the plaster that had stuck between her teeth.

C A R L Y S I M O N

ELDORADO HOTEL
SANTA FE, NEW MEXICO

HER BEDROOM
NEW YORK CITY

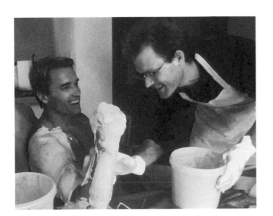

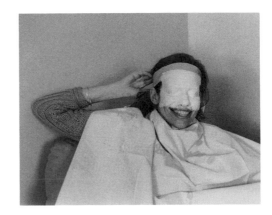

BODY CASTING

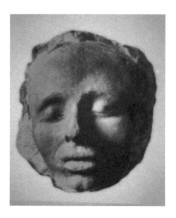

EGYPTIAN

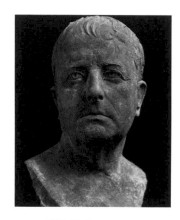

MAN OF THE REPUBLIC

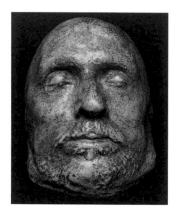

CROMWELL

IN PERSPECTIVE

Direct impressions of the human figure, living and dead, have been made for centuries. Used primarily for documentation, reference, and archive, these haunting sculptural relics seem to manifest an inherent power derived from their direct connection with the life and flesh of their long-departed subjects. These ancient casts have done what they were supposed to do and then some. In spite of the powerful statement they make, most life and death masks cast before the late twentieth century lack both expression and detail and very often contain obvious distortions due to the primitive molding techniques. Only recently has there been interest in developing new techniques and methods of life casting that allow this art form to reach its fullest potential. • The earliest example I have found of a death or life cast is a 4,000-year-old Egyptian mask. It was uncovered during the excavation at Saqqara in 1907 in the temple of Teta, a king of the sixth dynasty (c. 2325–2180 B.C.). Writes J. E. Quibbell in his book *Excavations at Saqqara*: "The face is a remarkable one: it is easy to believe that this person was of importance in his day. Now, of whom could a death mask be needed in the temple of Teta, save of Teta himself or, possibly, his queen? It may well be that statues of the king were made close by, and that this mask, after serving its purpose as a model to the sculptors, was buried in the sand...." • It is likely that Republican Roman sculptors used life casts as models for the starkly realistic portraits they created. To me these late Republican portrait heads shout "life cast." • In Europe, beginning in the fourteenth century, it became increasingly popular to make death masks of famous men and women. The masks were made to preserve some aspect of a precious yet brief existence and to immortalize the mighty. Tradition called for the mask-maker to be on hand at the deathbed so as to document—shortly after the moment of the spirit's departure—the last physical form of the subject's existence on earth. This reaching for permanence and for perpetuation, not of the works of the person or their ideas but of the physical form of their face, inspired casters to immortalize the features of Dante, Martin Luther, Oliver Cromwell, Jonathan Swift, Napoleon,

CRO-MAGNON CASTING
(A prehistorical fantasy)

The Stone Age. Shadows dance across a wall as a glowing fire illuminates a group of people deep in a dark cave. They watch intently as a woman performs an uncanny ceremony. On the ground lies a brave hunter, a young man who on this day was not so lucky. The mammoth had suddenly turned and the hunter was crushed. Now his body lies before the fire and the woman is taking a bit of clay from the mound at her side. Carefully and gently she begins to press the clay over the fallen hunter's face. When she judges the thickness of the clay to be just right she removes a glowing faggot from the fire. Uttering soft intonations, she passes the burning ember back and forth over the clay mask. Her clan watches, solemn, absorbed. She places more wood on the fire and kneels once more at the man's side. In the light of the rising flames, she places her hands on either side of the clay mask and begins to slowly pull it off. All watch as she stands and holds the mask over her head, the inside facing the fire. A cry rises from the group; looking back through the fire they see the spirit face of the dead man floating in the mask!

Walt Whitman, Leo Tolstoy, and James Joyce, among others. These death masks are a tribute to the men whose friends and followers couldn't bear the thought of these faces being gone forever. • Though vague, expressionless, and somewhat ghoulish, these death masks satisfy our desire to know what these men really looked like. The disappearance of the face is denied and arrested. Death and decay are somehow thwarted, and the face remains. • Life casts look different from death masks. Although the impulse may be similar—to preserve, in permanent form, someone's facial features— the resulting sculptural document is of a completely different nature. Historical life casts from this era, though still somewhat expressionless, do show the firmness of flesh of a living being. The seventeenth-century life cast of Isaac Newton by Roubiliac and the 1812 life cast of Beethoven are interesting but still frustratingly vague. The life cast of Keats, however, is a wonderful portrait. Made in 1818 when the poet was twenty-two years old, it shows

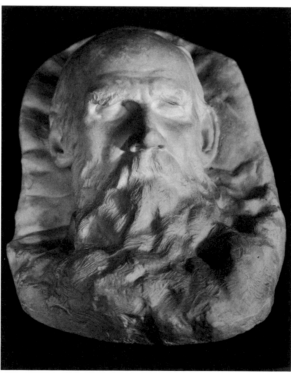

TOLSTOY

a refined and sensitive face, deep in thought and full of life, the closed eyes about to open and look straight into ours. • William Blake's (1757–1827) life cast was obviously made by a skilled mask-maker. It is one of the few historical masks that appear fresh and expressive. You can see extraordinary detail in the skin texture and in how the nostrils are slightly dilated from the straws

placed there for breathing. The expression on Blake's face, a wonderful grimace, suggests he was not exactly enjoying himself, which is not surprising considering the uncomfortable process he probably had to endure. This is perhaps the single greatest hurdle for the life-caster. How does one transcend an encumbering technique to achieve an accurate portrait with a natural expression? • One of the most remarkable figures in the history of face casting was an indomitable little French women born in 1760 with the name Marie Grosholtz. By the time she died, ninety years later, she had achieved international fame for herself and her London wax museum as Madame Tussaud. She learned her craft while working in Paris as an assistant to her uncle, Dr. Curtius. This colorful character had forsaken his medical training to pursue a career creating lifelike portraits in wax. The portraits were made by first taking an impression of the sitter's face in plaster. Clay was then pressed into this mold, and when it was removed, it was refined before making a final plaster mold into which hot wax was poured. The completed portraits, furnished with real hair and glass eyes and mounted on mannequins' bodies dressed in period costume, were a popular attraction. In an age before photography, film, and television, the Curtius waxworks allowed a curious public an up-close look at the saints and sinners of revolutionary

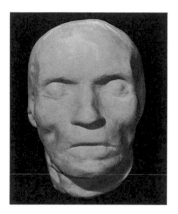

BEETHOVEN

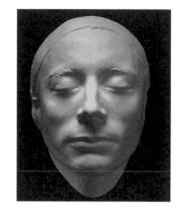

KEATS

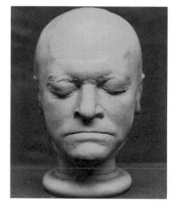

BLAKE

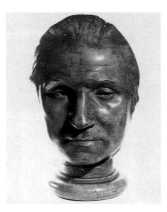

WASHINGTON

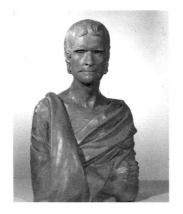

JEFFERSON

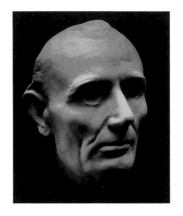

LINCOLN

Paris, including Marie Antoinette and Louis XVI, Marat, Madame Du Barry, Danton, Robespierre, and others. Many of the portraits Marie Grosholtz produced at this time were from death masks made on the severed heads of guillotined revolutionaries, some of them her dear friends! In her memoirs, she describes herself as "shrinking with horror," but "eager to retain a memento." Was this a ghoulish professionalism on her part or a transcendent sense of duty as a chronicler of her era? Some of these historic masks may still be seen at Madame Tussaud's in London. • Other sculptors used life casts and death masks as a reference tool. The French sculptor Houdon (1740–1828) made life casts of Benjamin Franklin, George Washington, and others, as an aid in carving his sensitive and revealing marble portraits. • The American sculptor John Henri Isaac Browere, working from 1817 to 1834, created a remarkable group of life-cast portraits. Browere made molds of James Madison, Thomas Jefferson, John Adams, Martin Van Buren, and many others. Browere would carve open the eyes of his portraits and model the hair in plaster, often adding a few folds of toga drapery around the shoulders. Although this makes for a rather incongruous mix of naturalism with neoclassical convention, they remain some of the most authentic and personal portraits from this era. • I am sometimes asked, jokingly, if I have ever asphyxiated anyone or had someone become permanently stuck in a mold. This popular notion of the hazards of life casting

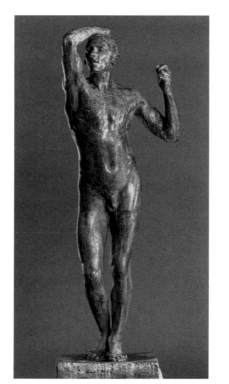

THE AGE OF BRONZE

has some basis in fact: Browere did almost kill Thomas Jefferson. In a letter to James Madison, Jefferson tells the story: *I was taken in by Browere. He said his operation would be of about twenty minutes and less unpleasant than Houdon's method. I submitted therefore without enquiry but it was a bold experiment on his part on the health of an octogenarian* [Jefferson was eighty-two], *worn down by sickness as well as age. Successive coats of thin grout plaistered on the naked head, and kept there an hour, would have been a severe trial of a young and hale person. He suffered the plaister also to get so dry that separation became difficult & even dangerous. He was obliged to use freely the mallet & chisel to break it into pieces and get off a piece at a time. These thumps of the mallet would have been sensible even to a loggerhead. The family became alarmed, and he confused, till I was quite exhausted, and there became real danger that the ears would separate from the head sooner than from the plaister. Now I bid adieu forever to busts and even portraits.* • Abraham Lincoln's gaunt features were molded in 1860 by his brother-in-law, Leonard Volk. Years later, sculptor Daniel Chester French used Volk's life cast as a reference for modeling the face of the monumental Lincoln sculpture in the Lincoln Memorial. • When French sculptor Auguste Rodin presented his first life-size work, *The Age of Bronze*, in 1877, a critic suggested that perhaps it had been cast from life. Rodin was furious. Accusing a sculptor of offering up a

mere life cast as a genuine sculpture was a potentially ruinous slander. With injured pride the artist fought back tooth and nail, finally winning complete vindication three years later when the controversial sculpture was purchased by the state and erected in the Luxembourg Gardens. • It was understood that a sculpture was a sculpture and a life cast was, well, something else entirely, even though many of the sculptors of the day dabbled in it. There is a beautifully expressive and detailed cast of Rodin's hand holding one of his own small sculptures. Daniel Chester French delighted in casting the hands of his guests. Portrait sculptor Jo Davidson made life casts of friends and visitors. When the American sculptor Malvina Hoffman travelled around the world in the 1930s sculpting portraits for the Hall of Man in Chicago's Field Museum, she also made life casts of hands, feet, and ears to doc-

DE ANDREA: THE SPHYNX

ument better the tremendous variety she found. • The place of life casting in the arts was clear. It was a useful tool, like a blueprint or a photograph—a convenient scientific measurement. But it was a poor relation to a genuine sculpture, in which a skilled artist stood back from his subject and, with a skilled hand and keenness of eye, created a likeness imbued with the sitter's character, as seen by the sculptor. • That notion was not seriously challenged until recently. The rough-cast, stark white figures of American life-cast pioneer George Segal, often set in the context of everyday tableaux, definitely have presence. There can be no doubt that Segal has used

life casting to express his view of life. What's more, he is serious about it. He works in life casting and makes no apologies for it. Life casting became art! • Or did it? When it comes to the work of John De Andrea and Duane Hanson and their hyperrealistic figures, it is easy to be confused. These two sculptors pushed life casting to its logical extreme (penultimate realism, absolute fidelity to nature) with faux-life mannequins that fool the eye and come alive late at night to search for their lost souls. To the extent that the success of their work depends on this illusion, they have a strong kinship with Madame Tussaud, and her work was never accepted as fine art. • What is the difference between Hanson's and De Andrea's creations and those of Tussaud? Why should one be considered a powerful new sculptural idiom, commanding high prices from art collectors, and the other have the status of a sideshow novelty, with admission charged to gawking viewers? I believe the answer lies mostly in a changing social and historical context. One of the many enormous cultural changes of the past century has been the extensive diversification of acceptable artistic media and the consequent willingness of people to find value in unexplored art forms. Pioneering artists including Ed Kienholz, Frank Stella, Bruce Nauman, and Yoko Ono have expanded the horizons of life casting in their search for a personal means of expression and have now brought it to a new level of potency and understanding—in an art world around which it had merely hovered for centuries.

ACKNOWLEDGMENTS

During the time I assembled this collection and book, I enjoyed the wholehearted and dedicated support of many people who advised and assisted me in every way. • I will always remain grateful for the immense generosity of all those people over the past sixteen years who put their faces and bodies in my hands and allowed me to cast them. I thank you for offering me your spirits. • The unceasing support and encouragement of Dean Ericson, my collaborator in work and partner in life, have made it possible for me to accomplish a project I could not have created alone. The College of Santa Fe has provided me with a light-filled studio, talented students, and a rich creative community since 1988. Art department chair Richard Cook has been tremendously supportive of this endeavor. • I thank Jan Miller, my high spirited literary agent, for introducing me to Cindy Black and Richard Cohn, publishers of immense talent and integrity. I salute my gifted editor, Nicky Leach, who was midwife for this project, pulling forth and shaping my thoughts and memories. Photographers Ross Baughman, Chris DeVitto, Vince Frye, Neil Jacobs, David O'Conner, Ashley Quintana, Nevin Shalit, Peter

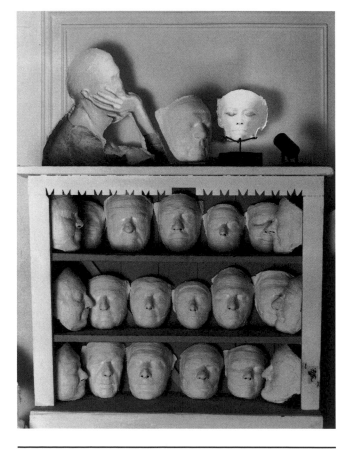

Simon, Susan Weineck, Malcolm Varon, and Amy Wells travelled along with me, expertly documenting my work. David Gorsek miraculously captured on film the spirit of the objects I have created. Principia Graphica worked the alchemy of design. • As president of the Touch Foundation, Robert Levithan has continually expressed belief in the importance of our work and has armed me with the strength to carry on. The generosity of Steve Gorlin, Patricia Du Mont, Phyllis Doane, Anne Morrow, Caroline Cobb, Parker Petit, and the support of the Jewish Guild for the Blind, the New York Lighthouse, the Dallas Lighthouse, the New Orleans Lighthouse, Gift Gardens, ExhibitsUSA, and the Guide Dog Foundation made it possible to create the "Please Touch!" exhibit. • Finally, heartfelt thanks go to my father for his inspiration, to my brothers and sisters for cheerleading, to Amy Roth, Michelle Roehm, and Kim Lew for research and production assistance, and to my Miracle Advisory Board: Mary Ann, Cecilia, MLC, Courtney, Glenna, Sally, James, Caroline, Laurie, Michael N., Eric, Robert, Jerry, Michael F., Lam, Sheldon, Joan, and Tarra for reminding me to breathe and smile.

PHOTOGRAPHY

8: HELEN KELLER QUOTATION courtesy of the American Foundation for the Blind 9: WILLA AND DEAN IN STUDIO by Neil Jacobs 10: NATALIA MAKAROVA EN POINTE by David Gorsek ©1992 Beyond Words Publishing and The Touch Foundation 11: TORSOS by David Gorsek ©1992 Beyond Words Publishing and The Touch Foundation 12: ANDREW SHALIT LIFE CAST ©1990 by Malcolm Varon 13: CLINT EASTWOOD BEING CAST by Ross Baughman 14: MUHAMMAD ALI FIST by David Gorsek ©1992 Beyond Words Publishing and The Touch Foundation 15: WILLA SHALIT LIFE CAST by David Gorsek ©1992 Beyond Words Publishing and The Touch Foundation 16: "PLEASE TOUCH!" EXHIBITION by Nevin Shalit 17: LIFE-CASTING WORKSHOP by Christopher De Vitto 18: DEBORAH KENDRICK QUOTATION courtesy of Deborah Kendrick and *The Cincinnati Enquirer.* 21–81: ALL PORTRAITS by David Gorsek ©1992 Beyond Words Publishing and The Touch Foundation 82: STING INNER MASK by David Gorsek ©1992 Beyond Words Publishing and The Touch Foundation 83: STING BEING CAST ©1983 by Sandy Gibson 85: CARLY SIMON BEING CAST by Susan Weineck 85: ARNOLD SCHWARZENEGGER BEING CAST by Ashley Quintana 86: EGYPTIAN courtesy of Brigham Young University, Provo, Utah 86: "MAN OF THE REPUBLIC" courtesy of the Museum of Fine Arts, Boston 86: OLIVER CROMWELL ©1990 by Malcolm Varon, courtesy of the National Portrait Gallery, London 88: TOLSTOY courtesy of Princeton University Library 89: BEETHOVEN ©1990 by Malcolm Varon 89: JOHN KEATS ©1990 by Malcolm Varon, courtesy of the National Portrait Gallery, London 89: WILLIAM BLAKE courtesy of the National Portrait Gallery, London 90: GEORGE WASHINGTON sculpture by Augustus Lenci, after the 1875 original by Jean-Antoine Houdon, courtesy of the National Portrait Gallery, Smithsonian Institution, Washington, D.C. 90: THOMAS JEFFERSON casting by John Henri Isaac Browere, courtesy of the New York State Historical Association, Cooperstown, N.Y. 90: ABRAHAM LINCOLN ©1990 by Malcolm Varon 91: "THE AGE OF BRONZE" sculpture by Auguste Rodin, courtesy of the Rodin Museum, Philadelphia (gift of Jules E. Mastbaum) 92: "THE SPHINX" ©1988 by John De Andrea, courtesy of Helander Gallery, Palm Beach, Florida 94: MASKS ON STUDIO SHELF by Peter Simon

CREDITS

For information on the "Please Touch!"
exhibition, life-casting workshops, and
lectures, please contact:

The Touch Foundation, Inc.
Route 7, Box 124WD
Sante Fe, New Mexico 87505
Phone: (505) 473-6557
Facsimile: (505) 473-6558

For an instruction booklet on life casting,
please contact:

Beyond Words Publishing, Inc.
13950 NW Pumpkin Ridge Road
Hillsboro, Oregon 97123
Phone: (503) 647-5109
Facsimile: (503) 647-5114

Proceeds from this book will benefit the
Touch Foundation for the Blind.